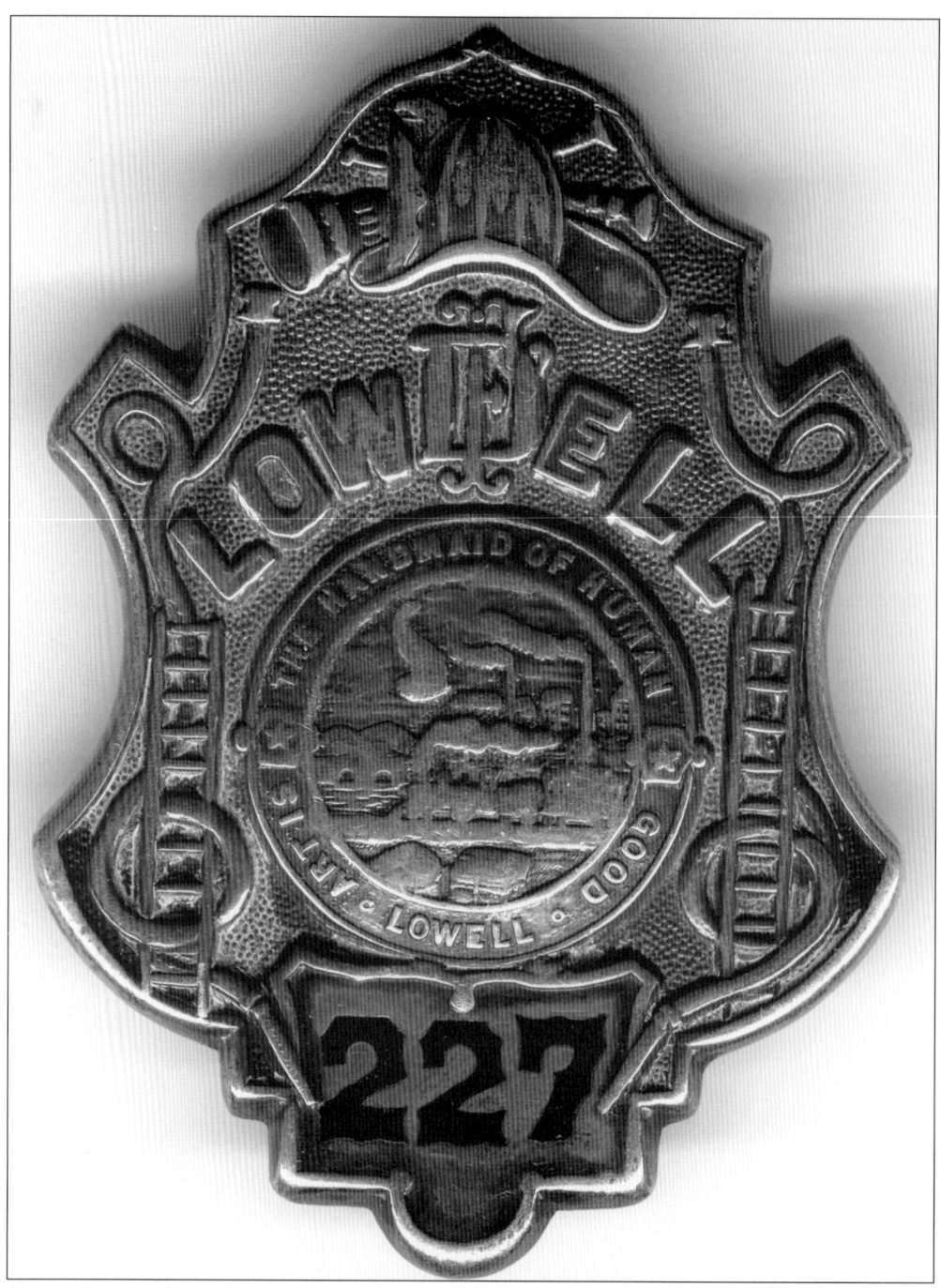

Shown here is the badge of a Lowell firefighter. It depicts the city seal which reads "Art is the Handmaid of Human Good." For over a century the badge has represented the source of identification for a member of the Lowell Fire Department. (Courtesy of Gerald Deschene.)

*On the cover:* Lowell firefighters walk through the debris of the Associates Building fire to find and extinguish remaining pockets of fire on April 27, 1924. (Courtesy of Dorothy Gardner-Casey.)

# IMAGES of America
# LOWELL FIREFIGHTING

Jason T. Strunk

Copyright © 2006 by Jason T. Strunk
ISBN 0-7385-4502-3

Published by Arcadia Publishing
Charleston SC, Chicago IL, Portsmouth NH, San Francisco CA

Printed in the United States of America

Library of Congress Catalog Card Number: 2006921284

For all general information contact Arcadia Publishing at:
Telephone 843-853-2070
Fax 843-853-0044
E-mail sales@arcadiapublishing.com
For customer service and orders:
Toll-Free 1-888-313-2665

Visit us on the Internet at www.arcadiapublishing.com

*For all the firefighters of Lowell, past and present,
who never fail to answer the bell, and for their families
who wait patiently for their safe return.*

# Contents

Acknowledgments     6

Introduction     7

1. The Early Years     9

2. Faces     27

3. Firehouses     41

4. Fire Apparatus     57

5. Fires and Rescues     71

6. General Alarms and Mill Fires     87

7. Call the Fire Department     103

8. Off the Job     113

# Acknowledgments

No one could tackle a project such as this without a tremendous amount of help. It has been a rewarding project primarily for the terrific people I have come to know through my research. Historical data came from numerous firefighters' personal scrapbooks, newspaper clippings, primary documents from the Center for Lowell History, and the chief engineer reports in the Pollard Memorial Library.

I would like to thank the following people and organizations for their help: First Fire Chief William Desrosiers and all the members of the Lowell Fire Department, especially deputy chiefs Patrick McCabe Jr. and Barry Finnegan; captains Marty Leary, Joseph Roth, Jeff Winward, John Weber, and Brian Callahan; lieutenants Paul Cronk, Sean Ready, Dennis Bergeron, and John Sullivan; firefighters Thomas Brothers, Bob Bugler, Bob Carroll, Tom Dowling, Frank Kelly Jr., Richard Mullen, Keith Porier, Mark Porier; my crew members from Engine 7, Paul Reid and Roberto Maldonado; and fire chief's office staff Pricilla Archambeault, Deborah Howard, Tara Coates, and Barbara Lemaitre.

Also, from the Lowell Retired Firefighters Association, Pres. Leo Sheridan, Vice Pres. Bill Dempsey, and secretary treasurer Roger Fournier; retired Lowell Fire Department members deputy chiefs Gerald Deschene, Mike Fitzgibbon, and Gerald Roth; captains Mike Murphy and George Rogers; lieutenants Ralph Carnevale, William Daly, John Dowling Jr. Robert Doyle, Gerald Peaslee, and Peter Sullivan; firefighters Bill Kiernan, Gerald Lavallee, Joseph Mahoney, Bill "Red" Mullen, Joe Saugeties, George Spenard, Jim Quealey, and Tom Rogers Jr.; the late Leon Fontaine, Tom Conlon, James Mulligan, David Gillis, and their families, Pauline Conlon, Janet Mulligan, and Gail Gillis.

I would also like to thank editor James Campanini and the great photographers from the *Sun of Lowell*, for the generous use of their great photographs you see on many of these pages; Sgt. Mickey O'Keefe of the Lowell Police, for saving so many of these photographs from being lost and allowing me to preserve them; director Dora St. Martin of the Pollard Memorial Library; Guy Lefebvre of the Lowell Gallery for his photographs and guidance; Martha Mayo, Janet Pohl, and the Center for Lowell History; Mehmet Ali of the Mogan Center; Denise Cailler, the board and members of the Lowell Historical Society for use of photographs from their collections; and Tom Langan for his initial collaboration on Up in Smoke presentation which spurred on this project.

In addition, fellow firefighters Capt. Mark Roche, Newton Fire Department; John Galla, Stoneham Fire Department; William F. Noonan, Boston Fire Department; Capt. Bob "Goose" Washburn and fire alarm operator Bill Cahill from the Lexington Fire Department; and captains Tom Conway and Tom Ferraro of the Billerica Fire Department.

For use of their personal collections, family photographs or information, I thank Joan D'Ambra and Dorothy Gardner-Casey (the family of John Gray), Mitch Gujeika, Ray Hilliard, Shawn Jasper, Mary-Elaine Jennings, my neighbor and friend John Kelley, Paul Klaver, Kevin Mann, Mary E. Nagle, and the family of Jaqueline F. Nagle, George Porier, Bob Stella, and Jim Wirth.

To my history teachers and professors, especially David Gramling, thank you for making history the best classes I ever took.

Finally, and most importantly, thanks to my wife, Angela, and family for their support and encouragement. I will always be grateful.

# INTRODUCTION

In the early 19th century, before Lowell was established as a city, fire protection existed primarily in the form of the Lowell United Fire Society's buckets. For each adult male, a leather fire bucket was required to be kept at hand, in the event of a fire. The citizens were the firefighters. Fire wards, prominent community men, were appointed in the town of Lowell in 1826 and given absolute authority to command in time of fire and the power to fine for refusal.

When fire wards met on the first Monday of March 1829, they decided the time had come to establish a fire department. A sum of $1,000 was approved to purchase a fire engine for the town and inquire about the legal establishment of the department. Within a month, an agreement with Thayer of Boston was established for a suction engine at a cost of $650. At 86¢ per foot, 250 feet of hose was purchased from a Mr. Boyd of Boston. The April town meeting appointed the fire wards to build a house for the new engine and keep ladders and hooks. Lowell's first firehouse was built on Locks and Canals Land on Central Street, in what is now the heart of downtown Lowell, and the engine called "Niagara" took up residence.

On February 6, 1830, by an act of the Massachusetts legislature, the fire department was established for the town of Lowell. That same year the first bylaws of Lowell Engine 1 were published, although no formal company of men existed until 1832. The board of engineers was established in 1832, and Lowell became a city in 1836. In 1842, men performing fire duty were awarded 20¢ per hour, the first monetary compensation for serving. By 1843, as many as 13 engines were in the city, but the majority were still privately owned by mills to protect their property. Between 1850 and 1851, hydrant pipes were laid and connected to the Belvidere reservoir, providing a water supply from the Locks and Canals Corporation. Until city water was introduced in December 1872, the private water system and standing reservoirs were the only source of water for firefighting.

The first steam-powered fire engine was purchased in 1859, and the first permanent firemen to drive and maintain them soon followed. In 1864, only one of the engines remained privately owned and the transition to a municipal department was nearly complete. Two more steamers were added in 1866, and in 1868, the department did away with hand-powered engines for front line service. The system of steam engines, hose companies, and ladder trucks was firmly established in the city by the 1870s. With heavier apparatus, horses began their period of prominence in the department; their numbers increasing through the start of the 20th century.

The fire alarm telegraph came to Lowell in 1871, improving the method of alerting fire companies to respond. The telegraph box replaced a system of ringing the ward section of the city on the market house bell and led to designated response areas for each company, a practice still in use today. Through the latter half of the 19th century, the department embraced new technologies with chief engineers advocating for chemical engines, fire extinguishers, horse-drawn carriages, stop and spray nozzles, cotton jacketed rubber hose, and a water tower. The threat of fire to life and livelihood was real in the densely populated city, and the department was successful in obtaining the necessary advances in firefighting capabilities. New firehouse construction began in 1875 and remained steady to serve the growing city into the 1920s. Many of the stations built still operate to this day. Attendance at conferences, professional networking between departments, mutual aid response, and the need for full-time staffed departments were

concepts that gained prominence as well. By 1898, the use of company names and antiquated titles of foreman, assistant foreman, and clerk were abandoned on department reports. Companies were designated by task and number, and the titles of captains and lieutenants were firmly established.

At the start of the 20th century, a majority of the department became full-time paid members, with many members residing in the fire stations in a paramilitary structure. With the continued growth of the city came an increase in the need for service. The number of calls topped 1,000 for the first time in 1910, the same year the first motorized apparatus was added. The department embraced motorization, and by 1925, horse-drawn apparatus responded to their last alarm. Prevention became a new focus of the department, as the causes of fires were tracked, many found to be the result of carelessness or worse, arson. The department was at the forefront in advocating for tougher building standards, regulation of flammable materials, and increased inspections of hazardous conditions.

The Lowell Fire Department became entirely permanent in 1920, and firefighters began to achieve gains in better working hours. Firefighting grew into a respected profession through the dedicated work of firefighters. Better equipment advances led to the addition of stronger aerial ladder trucks, larger pumps on engines, and the ability to carry water, a pump, and hose on the same engine, thus eliminating the need for separate hose companies. However, as the city aged and the economy rose and fell with the city's industries, fires became more prominent. In the latter half of the 20th century, entire neighborhoods became blighted and suffered their rash of fires. Whether it was Little Canada, Hale-Howard, the Acre, or Lower Centralville, all of Lowell's neighborhoods were impacted by fire, many times the result of arson. With the collapse of manufacturing in Lowell, many of the city's mills would fall as the result of fire.

Today the Lowell Fire Department responds to over 10,000 calls for service annually. With fire alarm systems, sprinklers, and more stringent codes, fires have decreased, yet the job and responsibilities of a Lowell firefighter have diversified and increased. Today, in addition to fires, the department responds to medical emergencies, hazardous material incidents, and rescue calls of every type. With the threat of terrorism, domestic preparedness has become yet another challenge for Lowell firefighters. Inspection programs and public education are now important avenues for firefighters to help prevent fires. The standing army to protect the public, advocated by chief engineers almost 150 years ago, is a reality, and the city is a better place for the service its firefighters perform for strangers at a moment's notice. The photographs in this book represent the proud tradition of the fire service in Lowell and are a tribute to all of Lowell's firefighters who have answered the call.

# One
# THE EARLY YEARS

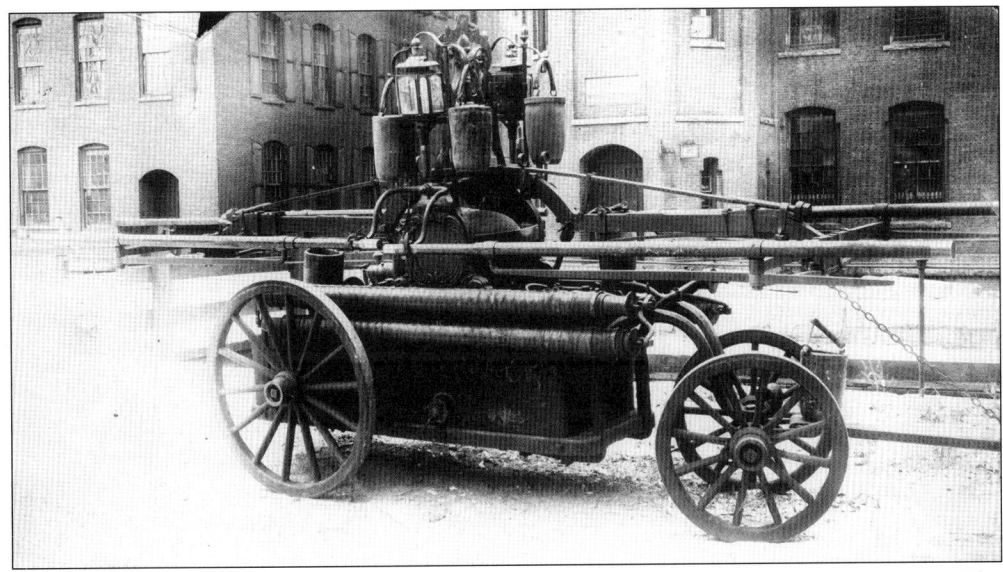

Merrimack Hand Engine No. 4 was owned by the Merrimack Manufacturing Company. The manufacturing interests in the city owned many of the city's early fire engines. The mills did allow their engines to be used outside their yards, but if the fire was not on mill property, they were manned only by any volunteers available. Merrimack No. 4 was manufactured by Hunneman in Boston and delivered to the city on February 12, 1848. Hunneman manufactured at least 11 engines that saw service in Lowell. (Courtesy of Lowell Historical Society [LHS], Lowell Museum Collection.)

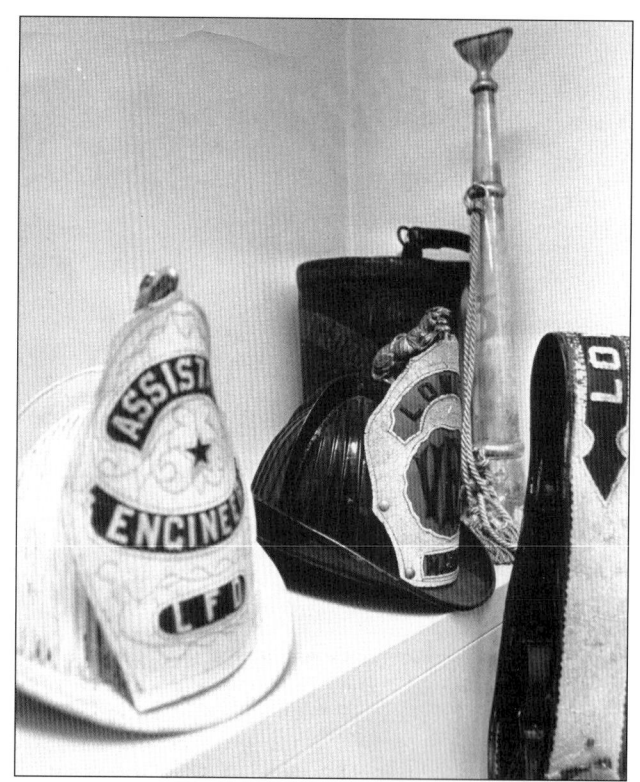

Early fire equipment on display at the fire chief's office in 1976 includes leather helmets and buckets, a silver speaking trumpet, and a leather parade belt. In the 1820s, the Lowell United Fire Society was one of the most active groups in the town. Members were required to keep leather buckets at hand, one for each male member of the household. They were required on the outbreak of a fire to proceed to the scene and form a chain, passing buckets of water. Fire wards, and later the board of engineers, carried speaking trumpets to shout orders at fire scenes. (Courtesy of the Sun of Lowell, photograph by David Brow.)

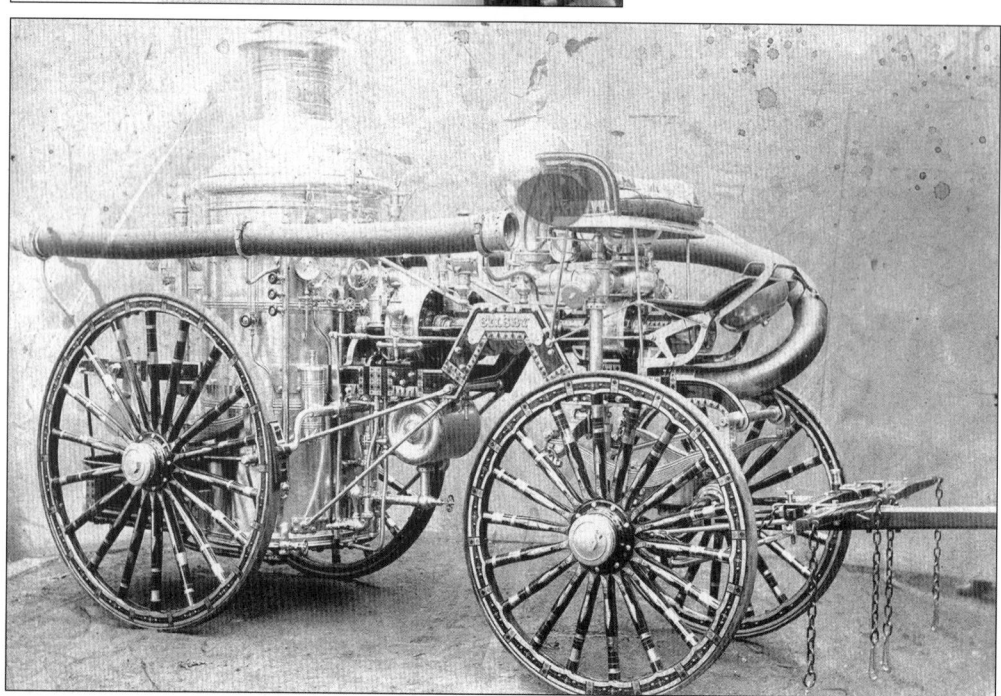

Lowell's first steam engine Wamesit Engine 3, built by the Silsby and Mynderse Manufacturing Company of Seneca Falls, New York, is shown in the manufacturer's photograph dated 1859. (Courtesy of Shawn Jasper.)

### Instructions to Key-Holders.

1. Alarms are to be given from the box nearest the location of the fire.
2. Upon the discovery or *positive* information of a fire, you will unlock the box, pull down slide or hook *once* only, and let go. This gives the desired alarm all over the city, repeating itself five times.
3. Each box contains a small bell, which, if heard before you pull the hook, indicates that the alarm has been previously given from another box; in such cases *do not* pull the hook until you are sure the alarm has been completed.
4. Never signal for a fire seen at a distance; never touch the hook except to give an alarm of fire. Give an alarm for no cause other than actual fire. Be sure and *close the door* on leaving the box.
5. ALARM BELLS are located as follows: COURT HOUSE, on Chapel Hill; FRANKLIN SCHOOL-HOUSE, Middlesex st.; ST. MARY'S CHURCH, Suffolk st.; HIGH-STREET CHURCH, East Merrimack st.; MARKET HOUSE, Market st.
6. Never let the key go out of your possession, unless called for by the Chief Engineer. If you change your residence or place of business where the key is kept, return the key to the same officer.

Alarms are sounded as follows: 1—then an interval of seven seconds; then 1—1; then an interval of twenty seconds; then repeat, which indicates Box 12, Market House. All compound Nos. struck the same

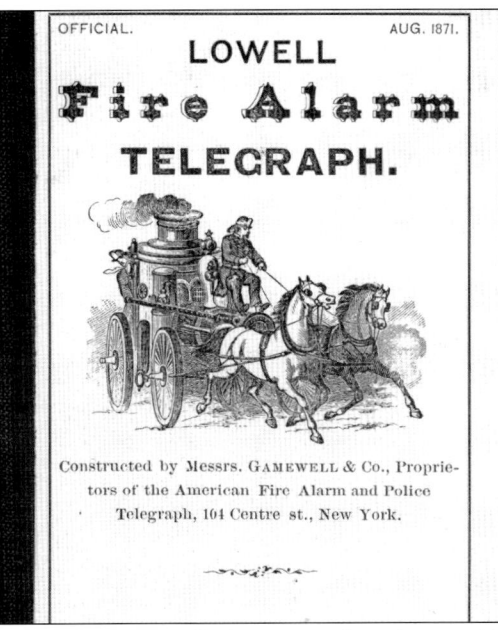

OFFICIAL.    AUG. 1871.

# LOWELL
# Fire Alarm
# TELEGRAPH.

Constructed by Messrs. GAMEWELL & Co., Proprietors of the American Fire Alarm and Police Telegraph, 104 Centre st., New York.

In 1871, the Gamewell Fire Alarm Telegraph System was installed, going online August 19. The original system contained 14 miles of wire and 32 signal boxes. Gongs were placed in the firehouses and strikers with bells in the armory building on Market Street, Chapel Hill Court House, Franklin School House on Middlesex Street, St. Mary's Church on Suffolk Street, and the High Street Church on East Merrimack Street. Wires were also run into the jewelry store of J. Raynes and Company at 43 Central Street by whom standard time was struck at 1:00 p.m. each day. Supt. Torrey E. Stratton, also engineer of Steamer 3, oversaw the system. The coded number of the box gave a much more accurate location of the fire alarm location. Previously only the city ward number of the fire was rung. The first alarm was sounded from box 34, five days after installation. (Author's collection.)

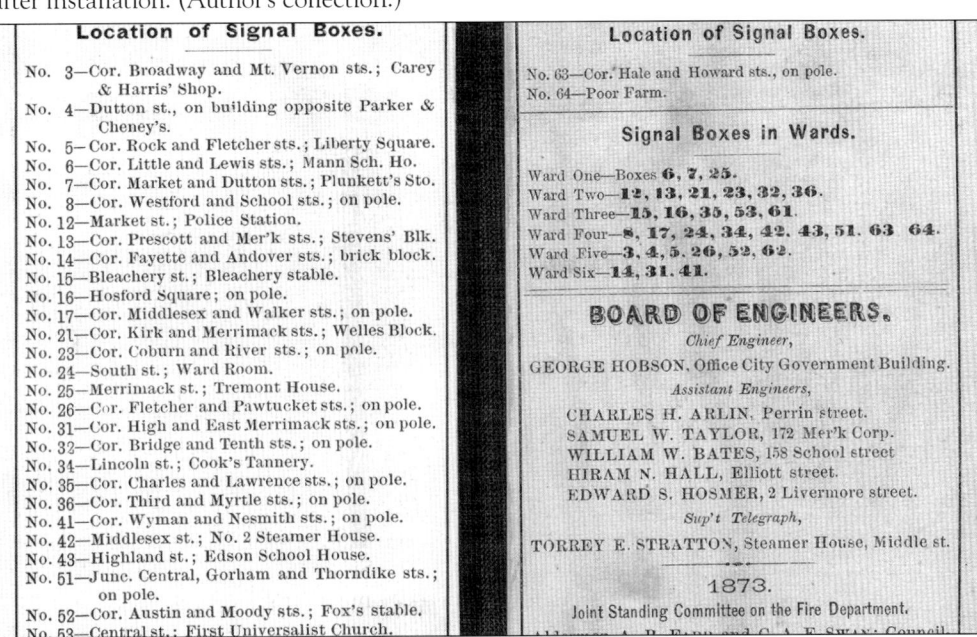

### Location of Signal Boxes.

No. 3—Cor. Broadway and Mt. Vernon sts.; Carey & Harris' Shop.
No. 4—Dutton st., on building opposite Parker & Cheney's.
No. 5—Cor. Rock and Fletcher sts.; Liberty Square.
No. 6—Cor. Little and Lewis sts.; Mann Sch. Ho.
No. 7—Cor. Market and Dutton sts.; Plunkett's Sto.
No. 8—Cor. Westford and School sts.; on pole.
No. 12—Market st.; Police Station.
No. 13—Cor. Prescott and Mer'k sts.; Stevens' Blk.
No. 14—Cor. Fayette and Andover sts.; brick block.
No. 15—Bleachery st.; Bleachery stable.
No. 16—Hosford Square; on pole.
No. 17—Cor. Middlesex and Walker sts.; on pole.
No. 21—Cor. Kirk and Merrimack sts.; Welles Block.
No. 23—Cor. Coburn and River sts.; on pole.
No. 24—South st.; Ward Room.
No. 25—Merrimack st.; Tremont House.
No. 26—Cor. Fletcher and Pawtucket sts.; on pole.
No. 31—Cor. High and East Merrimack sts.; on pole.
No. 32—Cor. Bridge and Tenth sts.; on pole.
No. 34—Lincoln st.; Cook's Tannery.
No. 35—Cor. Charles and Lawrence sts.; on pole.
No. 36—Cor. Third and Myrtle sts.; on pole.
No. 41—Cor. Wyman and Nesmith sts.; on pole.
No. 42—Middlesex st.; No. 2 Steamer House.
No. 43—Highland st.; Edson School House.
No. 51—Junc. Central, Gorham and Thorndike sts.; on pole.
No. 52—Cor. Austin and Moody sts.; Fox's stable.
No. 53—Central st.; First Universalist Church.

### Location of Signal Boxes.

No. 63—Cor. Hale and Howard sts., on pole.
No. 64—Poor Farm.

### Signal Boxes in Wards.

Ward One—Boxes **6, 7, 25.**
Ward Two—**12, 13, 21, 23, 32, 36.**
Ward Three—**15, 16, 35, 53, 61.**
Ward Four—**8, 17, 24, 34, 42, 43, 51, 63, 64.**
Ward Five—**3, 4, 5, 26, 52, 62.**
Ward Six—**14, 31, 41.**

### BOARD OF ENGINEERS.

*Chief Engineer,*
GEORGE HOBSON, Office City Government Building.

*Assistant Engineers,*
CHARLES H. ARLIN, Perrin street.
SAMUEL W. TAYLOR, 172 Mer'k Corp.
WILLIAM W. BATES, 158 School street.
HIRAM N. HALL, Elliott street.
EDWARD S. HOSMER, 2 Livermore street.

*Sup't Telegraph,*
TORREY E. STRATTON, Steamer House, Middle st.

### 1873.

Joint Standing Committee on the Fire Department.

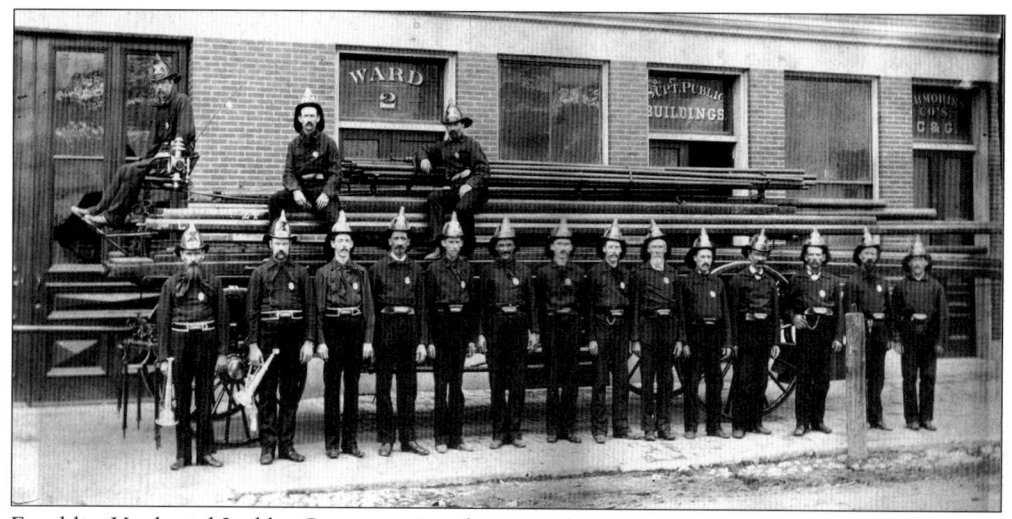

Franklin Hook and Ladder Company 1 is shown with one of their two carriages outside their quarters on Middle Street in 1878. This truck was a Juckett and Freeman model manufactured in Boston. A new tillered truck was put in service on December 18 that year. Holding the speaking trumpets are foreman Horatio Downs and assistant foreman Frederick Fuller. In the driver's seat is the company's only permanent department member, William Peabody. With 21 members, the truck company was the largest in the department. Located separately from the engine house a few doors down, the truck shared a home with the city paint shop, carpenter's shop, superintendent of public buildings, and the armory of companies C and G. (Courtesy of Patrick McCabe Jr.)

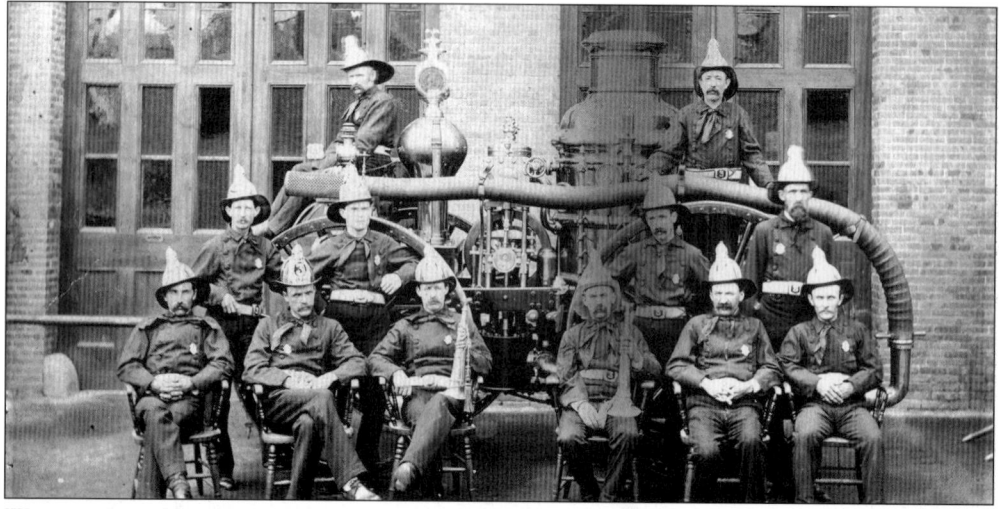

Wamesit Steam Engine Company 3 is pictured outside its Middle Street quarters in 1878. Built by Hunneman and Company, the steam engine was the company's second, put in service on November 9, 1866, replacing the engine put in service in October 1859. Engine 3 took up residence on Middle Street on April 1, 1866. The engine had two double-acting steam cylinders and two double-acting flange pumps, which could be operated independently in case of an accident. The boiler made enough steam to run the engine in five minutes. Pictured from left to right are (first row) James Adams, Frank Bowden, assistant foreman A. B. Smith, foreman J. H. Stackpole, Frank Hoyt, and D. W. Hilliard; (second row) E. J. Little, Frank Roark, J. W. Halstead, and J. G. Merchant; (third row) G. B. Whitney and E. L. Brown. (Courtesy of Patrick McCabe Jr.)

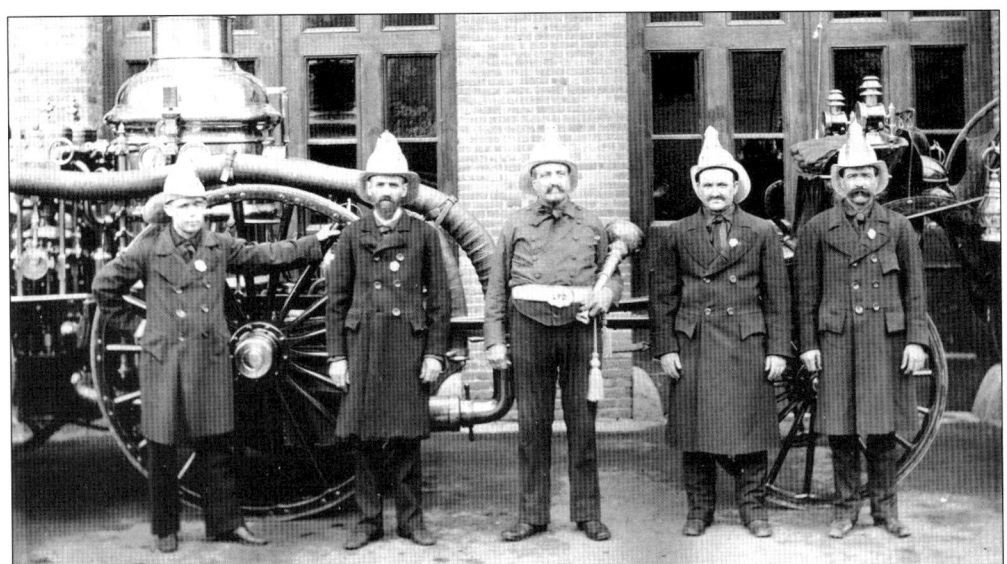

The board of engineers is shown outside the Middle Street Engine House in 1878. From left to right are assistant engineers Ruel Britton and Hiram Hall, chief engineer Samuel W. Taylor, and assistant engineers Edward Hosmer and James Norton. Only the chief engineer was a full-time employee at the time. Edward S. Hosmer would go on to lead the department as chief engineer. Chief Hosmer joined the department in 1856, was first elected chief in 1880, and served continuously as chief from February 7, 1888, to May 1, 1913. Britton would also serve a term as chief engineer. (Courtesy of Patrick McCabe Jr.)

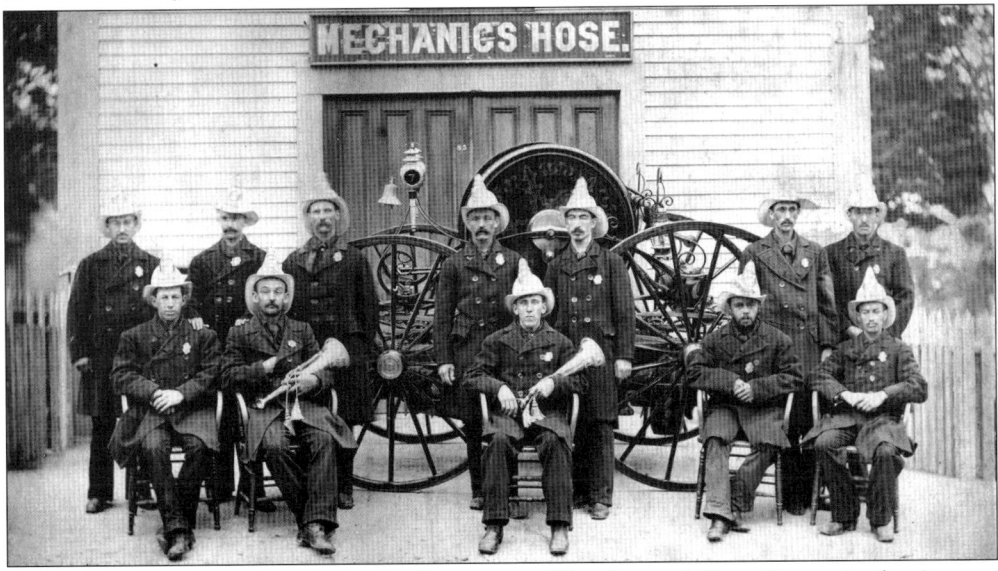

Mechanics Hose Company 7 stood at the corner of Fletcher and Cross Streets in the Acre on what is now the site of the firefighter's club. The company was renumbered from Hose 2 in 1876 to prevent confusion with engine company hose carriages. Their hand-drawn hose carriage was built in 1869 and carried 500 feet of hose. Photographed in 1878, the assistant foreman is S. O. "Puck" Wade on the left with trumpet, and the foreman is F. W. Osgood, on the right with trumpet. All the company members were call men, most employed in the construction trades. (Courtesy of Patrick McCabe Jr.)

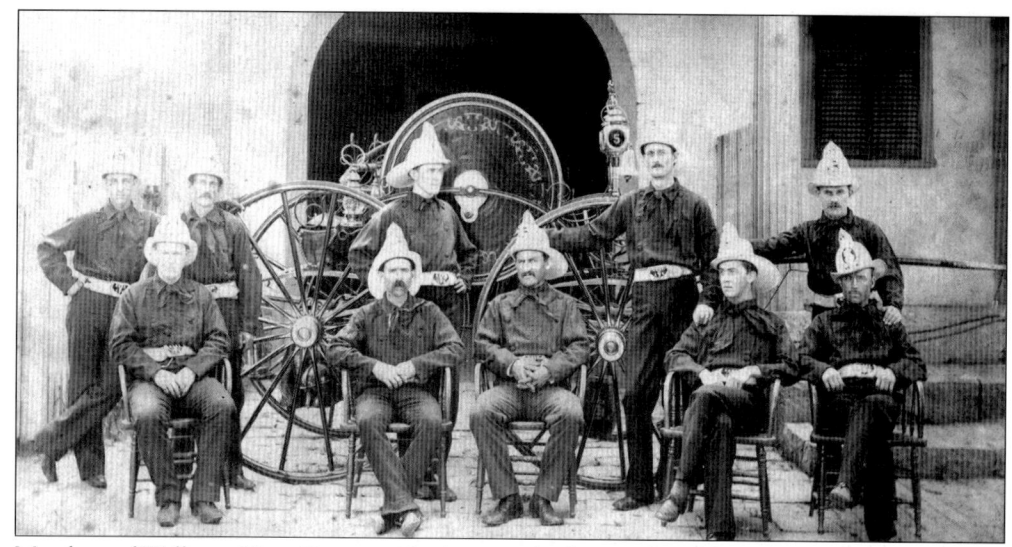

Members of Wellman Hose Company 5, photographed around 1877, are outside the arched doors of their wooden firehouse on Fourth Street in Centralville. The company was placed in service on December 1, 1873. Their hose carriage was built in 1869 and carried 500 feet of 2.5-inch-diameter leather hose. One of the company's etched glass hand lanterns is in the fire department collection of the Lowell Historical Society. All of the helmets worn by the members are white, and are most likely their parade helmets. Their black helmets for working at fires hang on the carriage just below the wheel at left. A numbered fire bucket hangs below the wheel at right, for use in putting out small fires quickly, without laying hose from a hydrant. (Courtesy of Patrick McCabe Jr.)

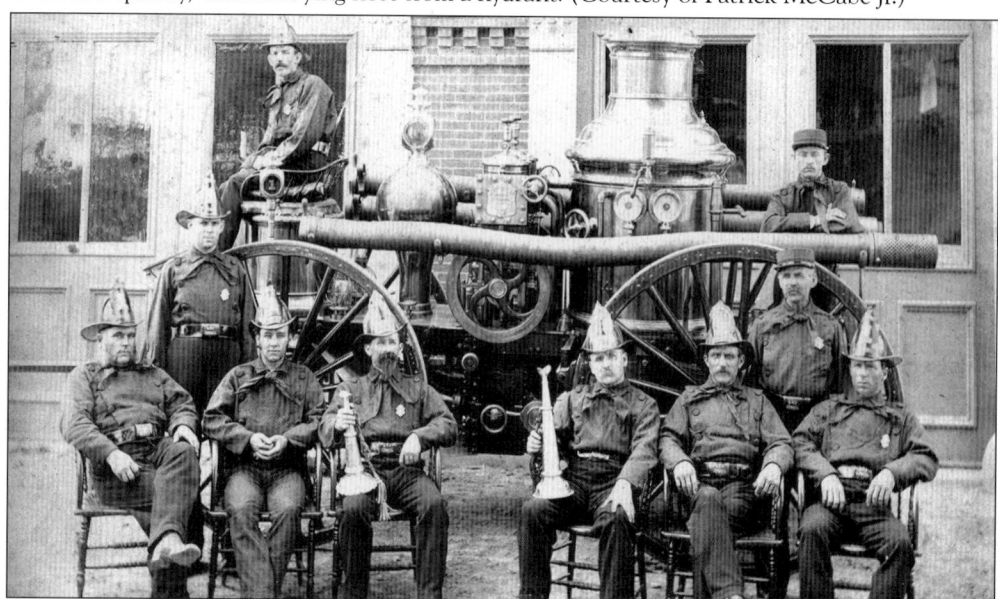

Hope Steam Engine 1, built by Union Machine Company of Fitchburg in 1870 with two double-acting steam cylinders, is in their company photograph in 1878. The company originally began service on May 1, 1866, as General Butler Steam Engine 1 on Middle Street, before relocating to its new Gorham Street home. From left to right are (first row) J. C. Jockow, G. W. Lovett, assistant foreman B. F. Crosby, foreman J. W. White, George Hustwick, and James Cowell; (second row) O. J. Gilbert and J. J. Locke; (third row) W. H. Grady and E. C. Kelley. (Courtesy of Patrick McCabe Jr.)

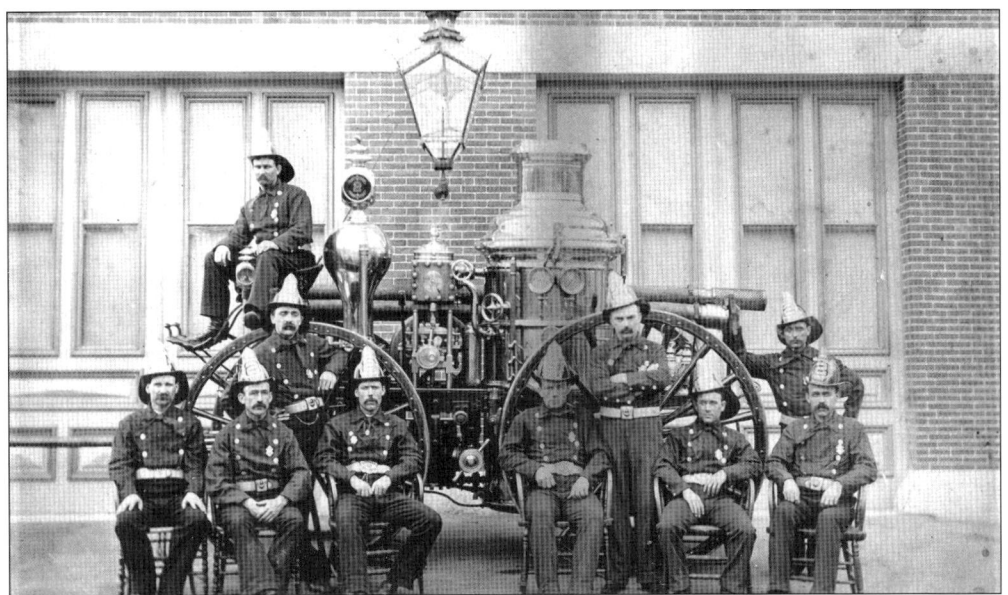

Torrent Steam Engine 2 is outside its quarters at 45 Branch Street. The company was photographed near the opening of its new engine house in 1877. The steamer is an 1868 Hunneman Model, received on February 28th. From left to right are (first row) Joseph Hill, S. E. Bartlett, assistant foreman M. J. Coolidge, foreman A. C. Stearns, clerk G. H. Hartford, and J. Crosby; (seond row) J. W. Abbott, Frank Foss, and C. S. Hibbert; (third row) permanent driver Henry Boynton. Missing is engineer George Maddocks. (Courtesy of Patrick McCabe Jr.)

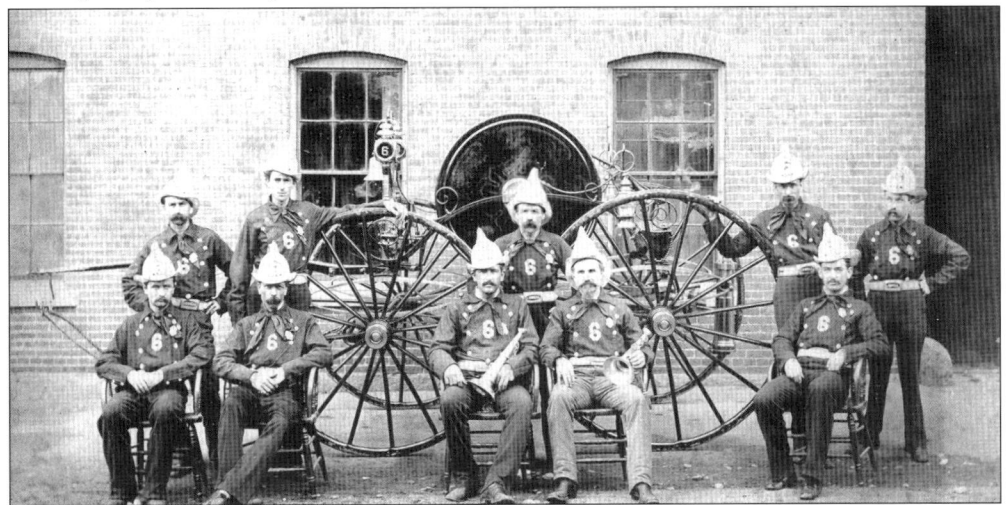

The original Warren Street firehouse was built in 1846, adjacent to the Middlesex Company. The Middlesex Company owned the building, and the city was allowed use it as long as an engine or hose company was kept there. Photographed in 1878, the company responded with an 1869 hand-drawn carriage. Foreman W. H. Hunt is holding a trumpet at left, and assistant foreman A. C. Walton is with the trumpet at right. One of the oldest continually operating companies at the time, the members wore their company number across their chests along with their city-issued silver badges. Ocean Hose Company 6 disbanded in May 1880, after 30 years of service, and was the last hand-drawn hose company in regular service. The Protective Company later took over the quarters. (Courtesy of Patrick McCabe Jr.)

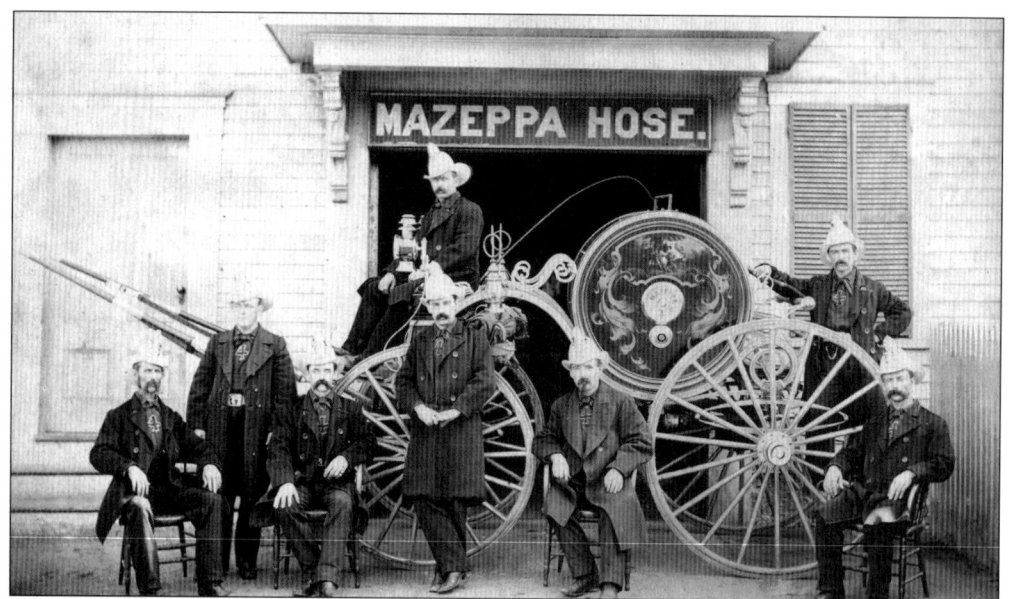

Mazeppa Hose Company 4 poses outside their wood frame firehouse on Fayette Street around 1877. Renumbered from Mazeppa 10 in 1868, the ornately painted carriage featured a mural inspired by a Lord Byron poem. Built by J. J. Wright of Lowell in 1871, the carriage carried 700 feet of hose. Seated in the driver's seat is Jere. Harrington. Standing from left to right are George Wyman, J. J. Quinlan, and Edward Meloy. Seated from left to right are G. R. Hussey, assistant foreman W. H. Halstead, foreman William King, and Edward Meredith. (Courtesy of Patrick McCabe Jr.)

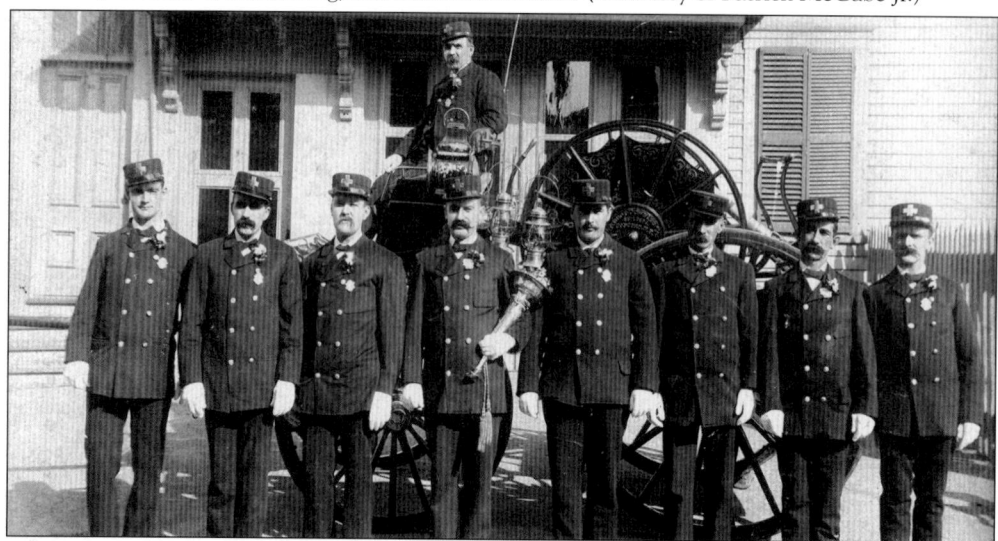

Members of Hose Company 4 pose around 1885. The uniforms have changed significantly, and the sign with the company's name has disappeared, likely indicating the beginnings of the department's shift toward a more paramilitary and permanent structure. The photograph was originally donated to the department by Winifred King Cheney, daughter of William King. From left to right are J. E. Burns, M. Connor, J. Dolan, J. J. Quinlan, Smith, E. Little, C. Morse, and J. E. Sullivan, with William King on the carriage. The horse-drawn hose carriage, built by the Abbott Downing Company of Concord, New Hampshire, was placed in the charge of the company in 1881. (Courtesy of Gerald Lavallee.)

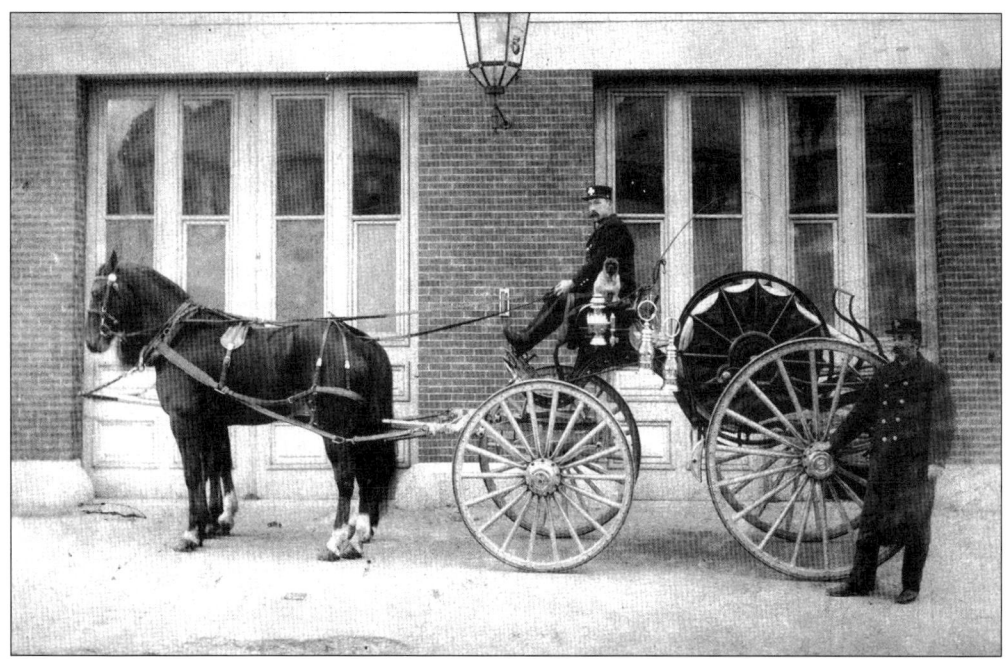

Wellman Hose Company 5's two-horse hose reel was built by the Manchester Locomotive works, in Manchester, New Hampshire. Photographed by the Marion Studio in 1883 are the company's two permanent members: Capt. C. F. Hemenway, standing, and driver A. E. "Bill" Kidder with the company mascot in the driver's seat. (Courtesy of Patrick McCabe Jr.)

The Worthen Street Baptist Church was destroyed by fire on December 31, 1887. An entirely wooden structure, it was noted at the time to be the first church property damaged by fire in many years. It would not be the last. St. Patrick's Church nearby on Suffolk Street was destroyed by fire on January 11, 1904. (Courtesy of LHS.)

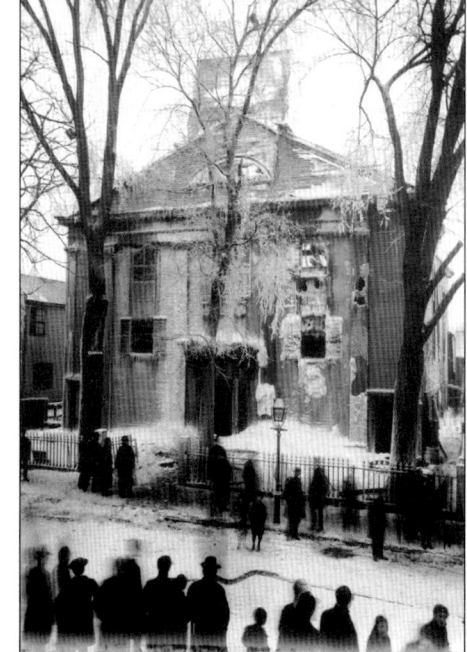

Worthen Street Baptist Church, after the Fire, December 31, 1887.

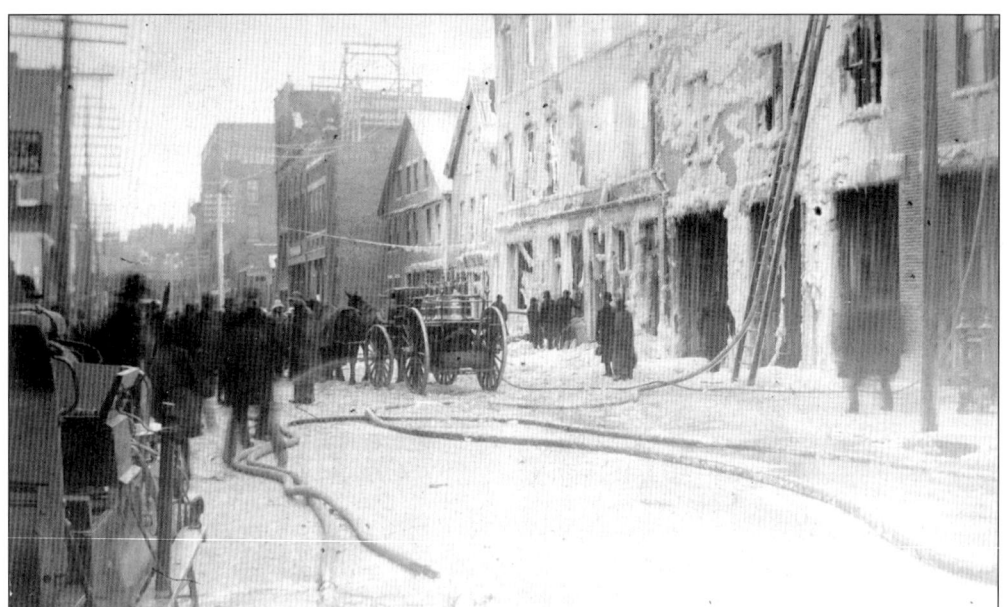

On January 11, 1888, a fire starting on the upper floors in the Armory Building on Middle Street spread to the Central Firehouse. Explosions caused by ammunition and gunpowder stored in the armory and extreme cold hampered firefighting efforts. Firemen lost valuable furnishings, pictures, furnishings, and a pool table. The apparatus stationed in the building was saved; the fire alarm system was heavily damaged. (Courtesy of LHS.)

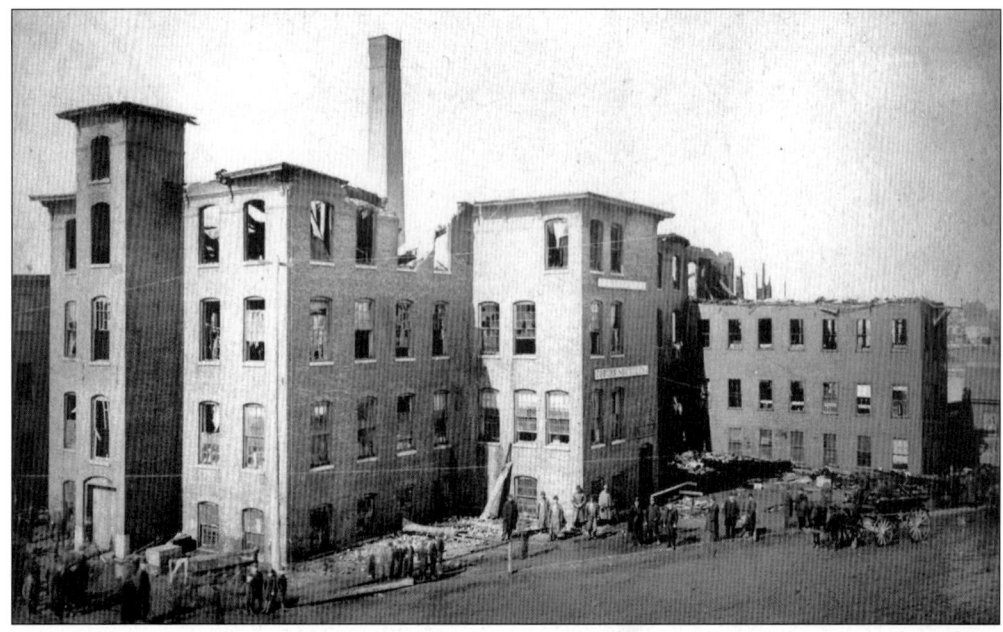

Shortly before 9:00 p.m. on March 29, 1888, Box 34 was sounded for fire in the Coburn Shuttle Company at Ayers City located off of Lincoln Street. The fire was two alarms, resulting in a loss of $46,548.35. The Pickering Hosiery Company and Criterion Hosiery Company were also damaged in the blaze. Firemen did not leave the scene until after 9:00 a.m. the next day. (Author's collection.)

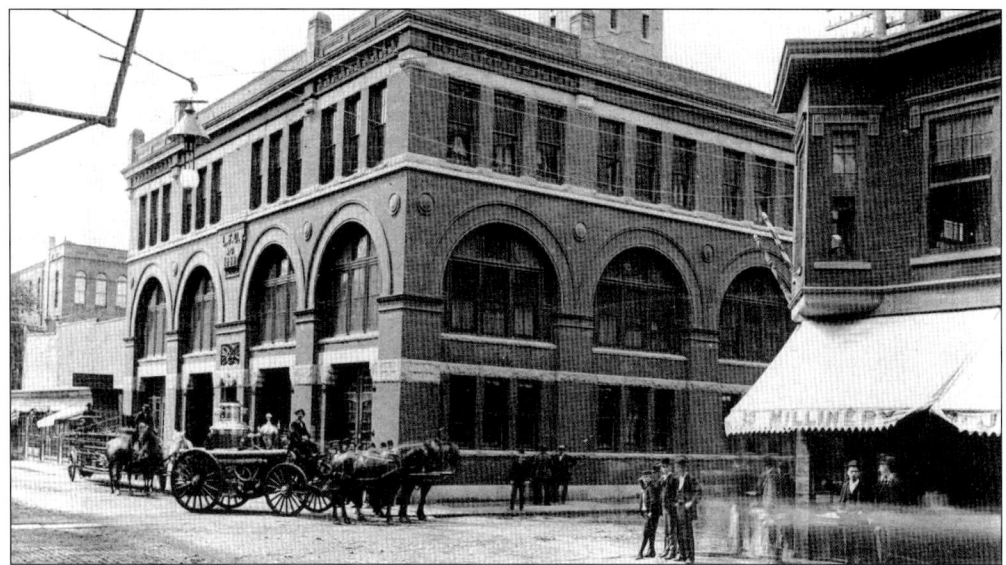

Engine 3 and Ladder 3 are shown outside the Palmer Street Firehouse in this photograph taken by the Citizen Newspaper Company in 1893. The new headquarters was built in 1889 after the burning of the Middle Street Engine House. In 1899, an addition was built on the Middle Street side, to accommodate the 1893 Hale Water Tower, which had previously been kept on High Street. Designed by the architectural firm of Merrill and Cutler, Chief Hosmer would remark after its completion, "I will say right here, without boasting, that we have the finest set of buildings in the United States." (Courtesy of Guy Lefebvre.)

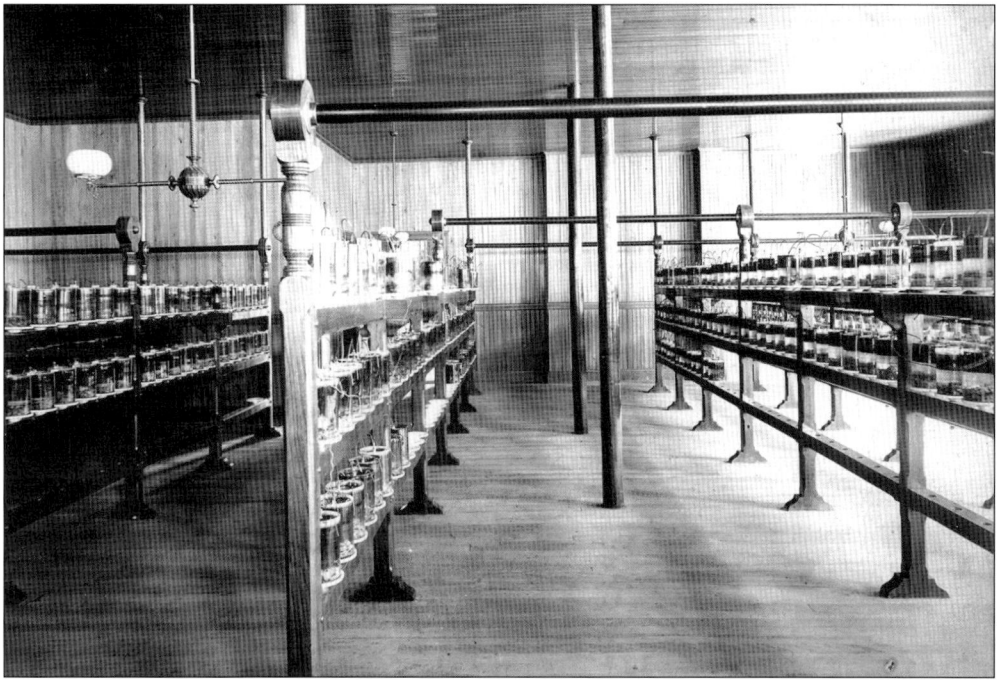

The battery room that powered the city's fire alarm system was located on the third floor along with the fire alarm operator's room at the Palmer Street firehouse. The power was supplied by 400 cups of gravity batteries. (Courtesy of LHS.)

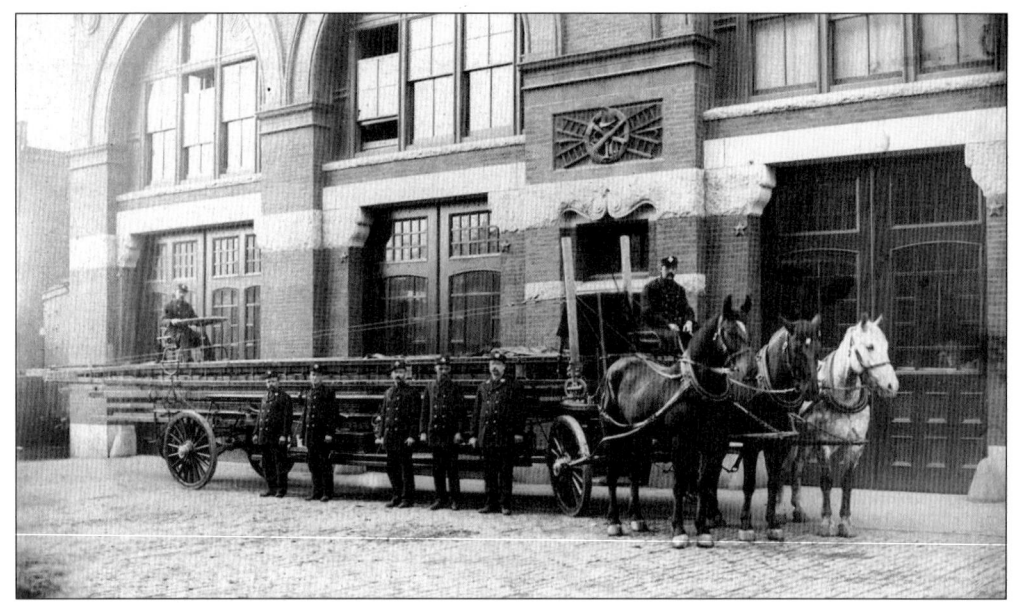

The new tillered Babcock Aerial Truck built by the Fire Extinguisher Company of Chicago in 1888 is shown outside the Palmer Street Fire headquarters. With an extension ladder of 85 feet, the truck weighed 8,100 pounds loaded. The company was put in service as Ladder Company 3 with the completion of the building. At that time, Ladder 1 was located on Fourth Street and Ladder 2 on Westford Street. (Courtesy of LHS.)

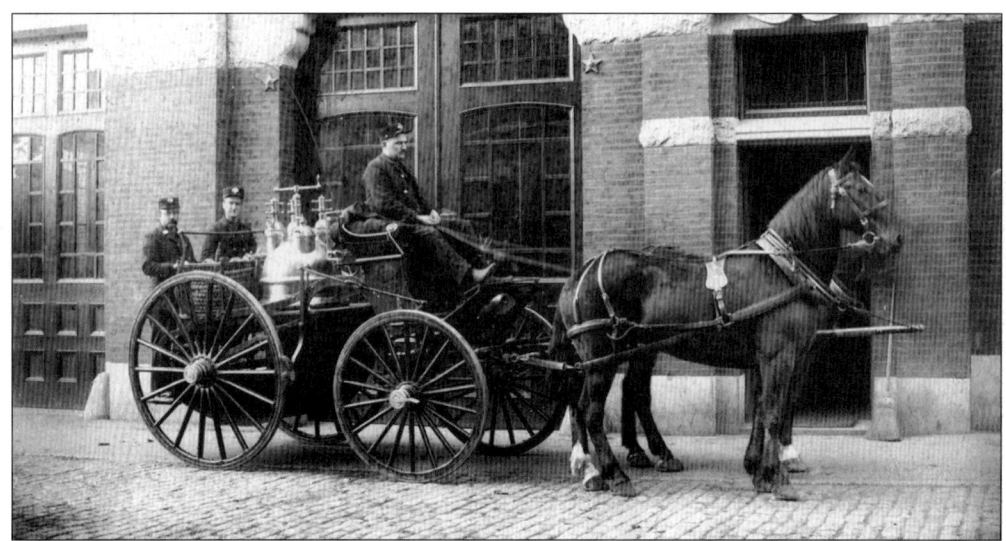

A Perkins Pattern Chemical Engine was purchased for $2,500 from the Chicago Extinguisher Company, to be put in service in April 1885. Three permanent firemen were appointed to the company, making the department total 28. Two horses drew the four-wheeled, double-tank engine, holding a total of 150 gallons. The company was stationed at the Race Street engine house. In 1889, due to its heavy weight, this engine was made into two chemical engines, placing one tank each on old hose reels and assigning them to Ladder Companies 2 and 3. Ladder 3's chemical Engine B is pictured here. Until the 1930s, more fires in the city were put out using chemical tanks than water. (Courtesy of LHS.)

Thomas Collins drives the steamer of Engine 1, pulled by a three-horse team to a fire, around 1890. Coal is burning in the boiler, building up steam pressure to allow the engine to pump. The Union Machine Company steam engine was in service from 1872 to 1908. Collins went on to become a captain in the department. (Courtesy of the Nangle family.)

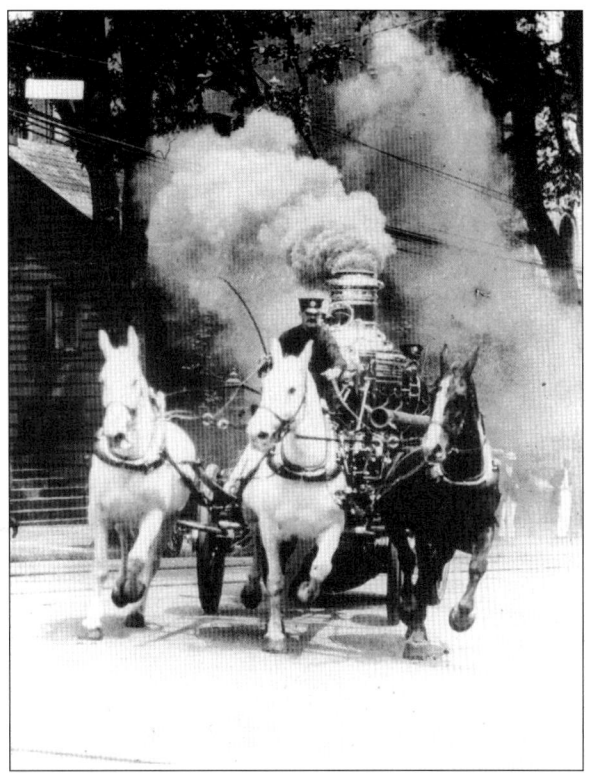

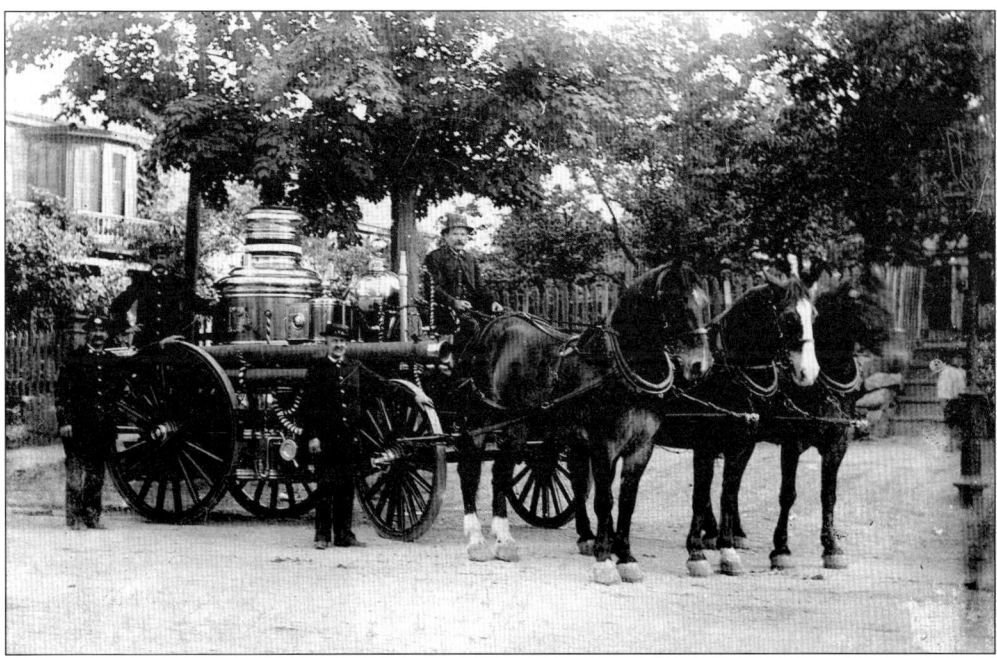

The Engine Company 6 steamer was built by Manchester Locomotive works in 1892 at a cost of $4083.70. When loaded fully, it weighed 9,300 pounds, requiring the three-horse team to pull it. Unlike many other companies, the members are not wearing bell caps or helmets, but straw hats. (Courtesy of Patrick McCabe Jr.)

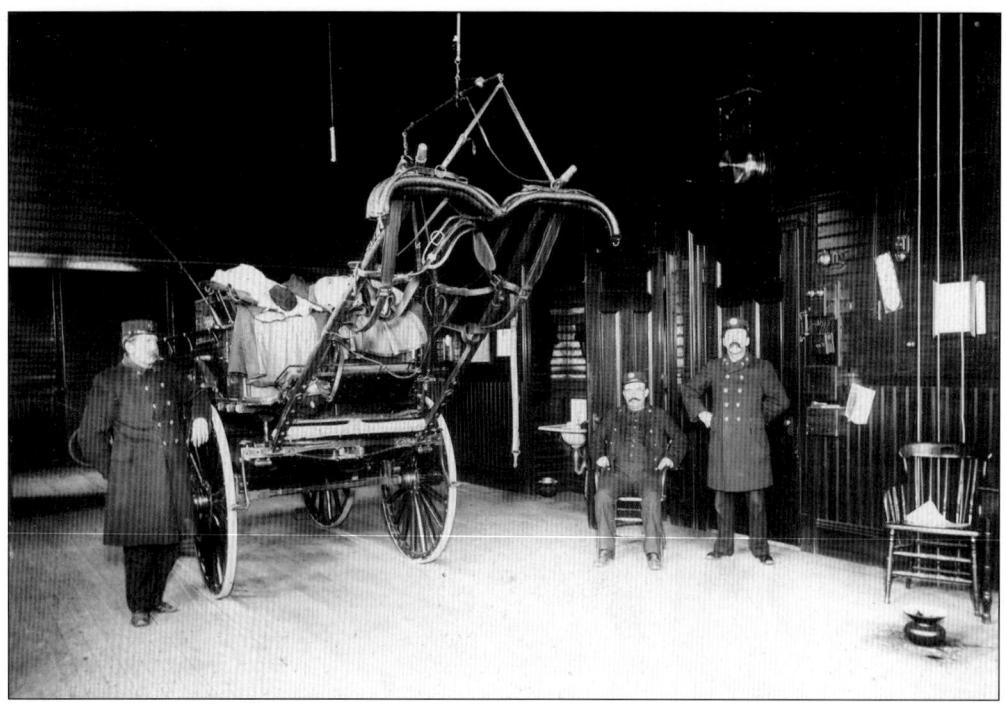

Capt. Joseph Jennings and the crew of Hose Company 11 pose with their carriage in their new quarters on Lawrence Street, shortly after the firehouse opened for service. The Berry swing harness hangs at the ready for the horse to hitch up and pull the wagon. New swinging harnesses, added to the department in 1882, cut down on horse fatigue by eliminating the need to constantly wear them. (Courtesy of Mary-Elaine Jennings.)

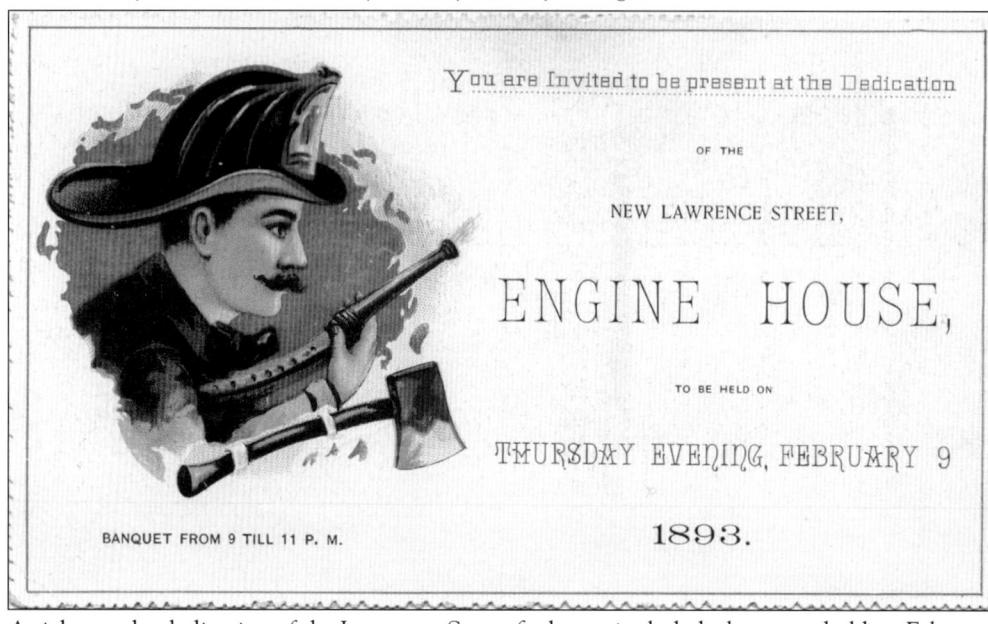

A ticket to the dedication of the Lawrence Street firehouse included a banquet, held on February 9, 1893. Although referred to as an engine house, the station did not have an apparatus with a pump on it until the 1930s. (Courtesy of Mary-Elaine Jennings.)

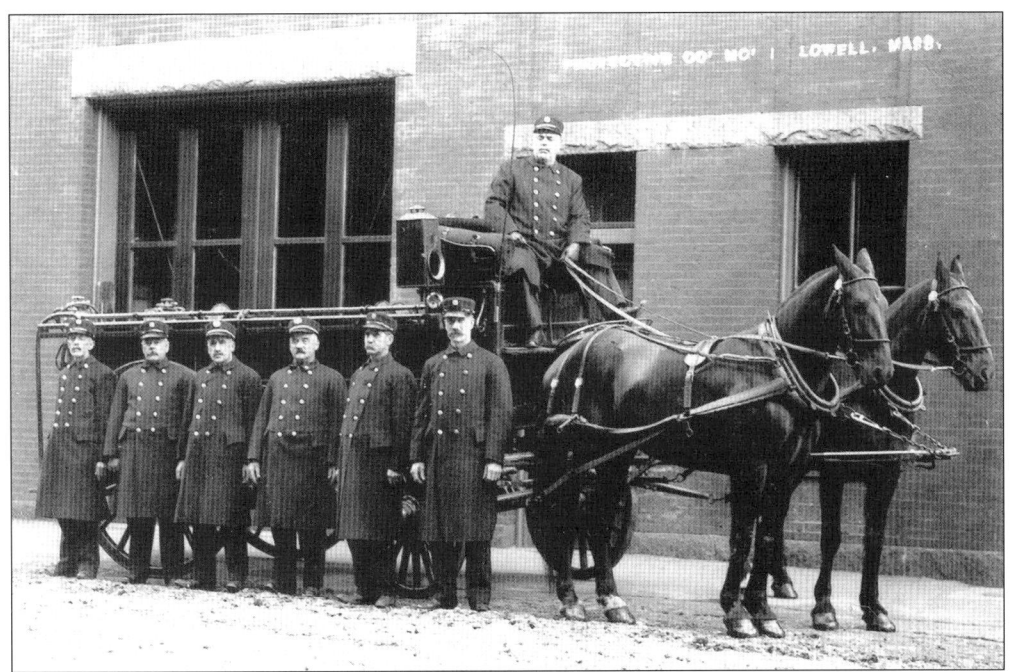

Lowell Protective Company 1 members and their patrol wagon stand outside their firehouse on Warren Street around 1900. Responding on every alarm, the Protective's primary job was to throw canvas salvage covers and protect the property inside a fire building. This company, also called the fire patrol, would later evolve into the department rescue company. (Courtesy of Mark Roche.)

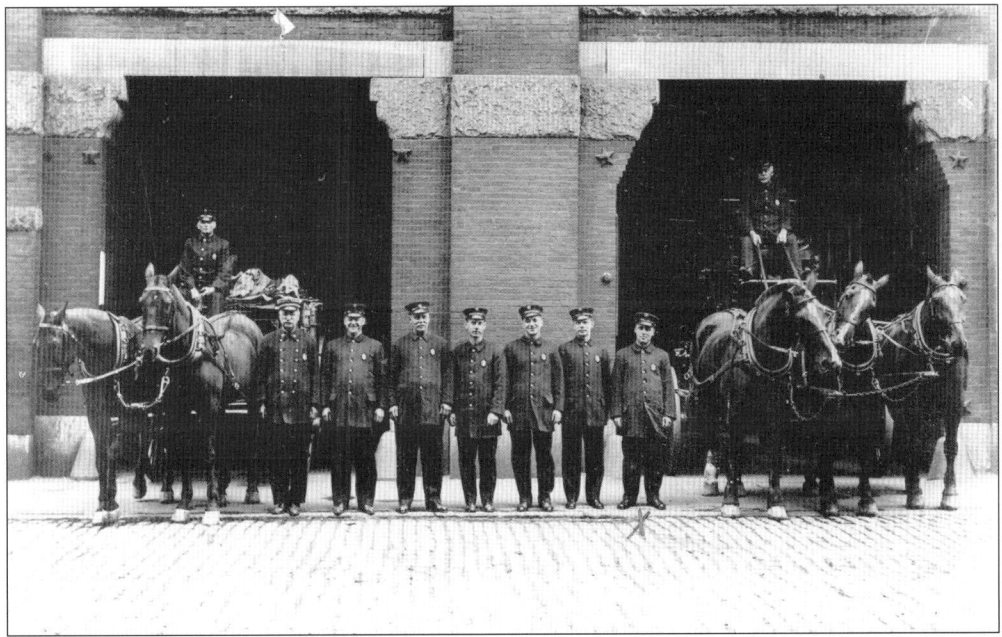

Engine Company 5 and its combination ladder and hose wagon are pictured outside its original location, the Mammoth Road firehouse. Engine 5 would later move to Fourth Street. The stars on its facade make the station easily identifiable. (Courtesy of Brian Callahan.)

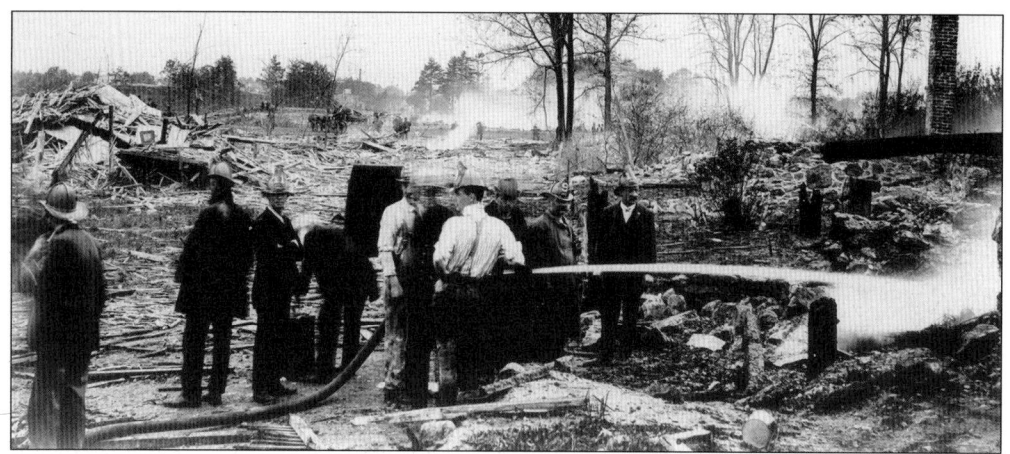

On July 29, 1903, an alarm from box 138 "called the department to one of the worst disasters that ever occurred in this vicinity, caused by the explosion of the magazines in Tewksbury." Upon arrival of Lowell fire companies, nine buildings were on fire and a number "blown to kindling wood," according to Chief Hosmer. The dead and wounded lay scattered over the ground with the exception of one woman whose body was taken from a burning building. Hose was removed from the fire wagons, which were then used to take bodies to the hospital and undertakers. Two horse teams loaded with powder were blown to small pieces. The largest piece found was the head and shoulders of one horse. No piece of the three men large enough to identify was ever found. Fragments of men and horses were found more than a quarter of a mile away. The Lowell Fire Department was on duty nearly eight hours. Members from Hose Companies 11 and 9 are in the photograph. (Courtesy of LHS.)

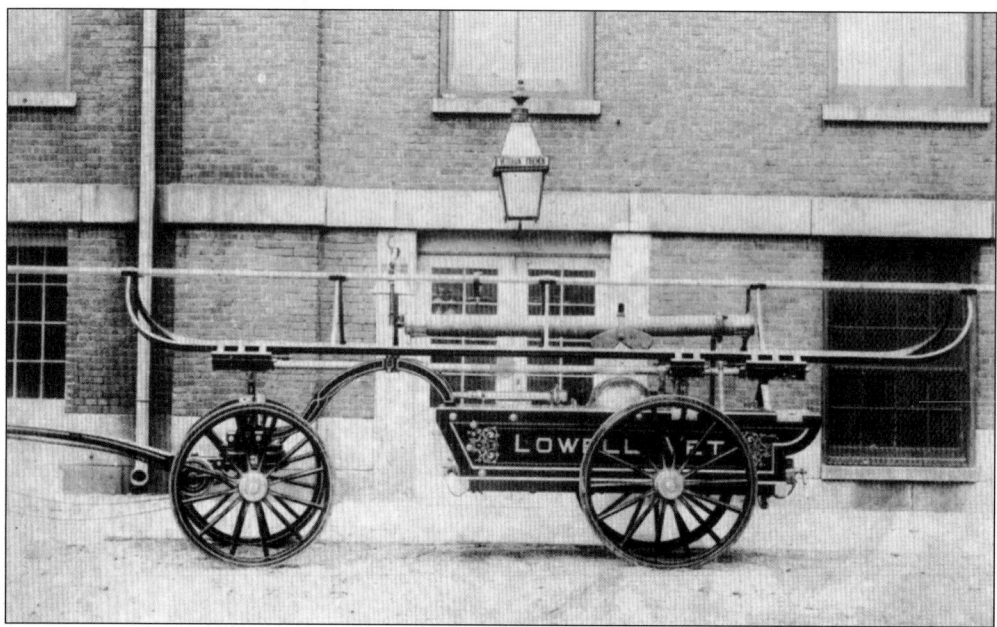

Shown is the Lowell Vet hand pumper. Although it never saw active firefighting duty in the city, "the Vet" replaced Merrimack 4 as the competition pumper for the Lowell Veterans Firemen's Association (VFA). The VFA was made up of former city volunteer firemen in muster competitions after hand engines were taken out of front line service in 1868. The Vet could pump a stream of water an average distance of 190 feet. (Courtesy of LHS.)

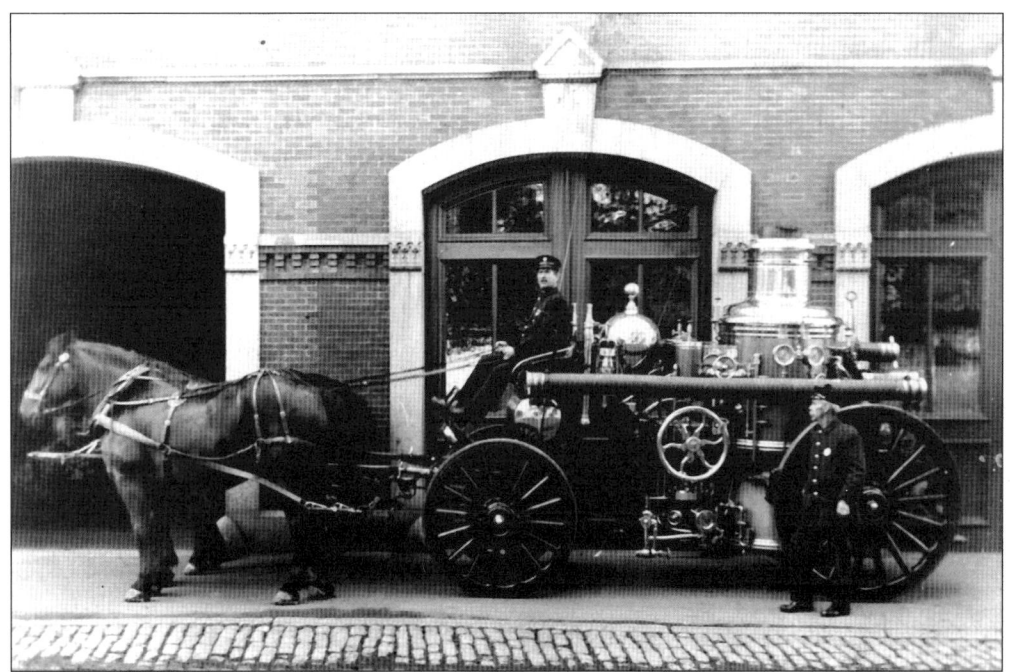

Engine 1's Amoskeag steam engine was one of the largest steam engines made in its day, with a pumping capacity of 900 gallons per minute. It was also the last steam engine Lowell would purchase. The full weight was 10,000 pounds loaded, requiring a team of the three largest horses in the department to pull it. The engine was reportedly powerful enough to operate the water tower by itself. (Courtesy of Mike Murphy.)

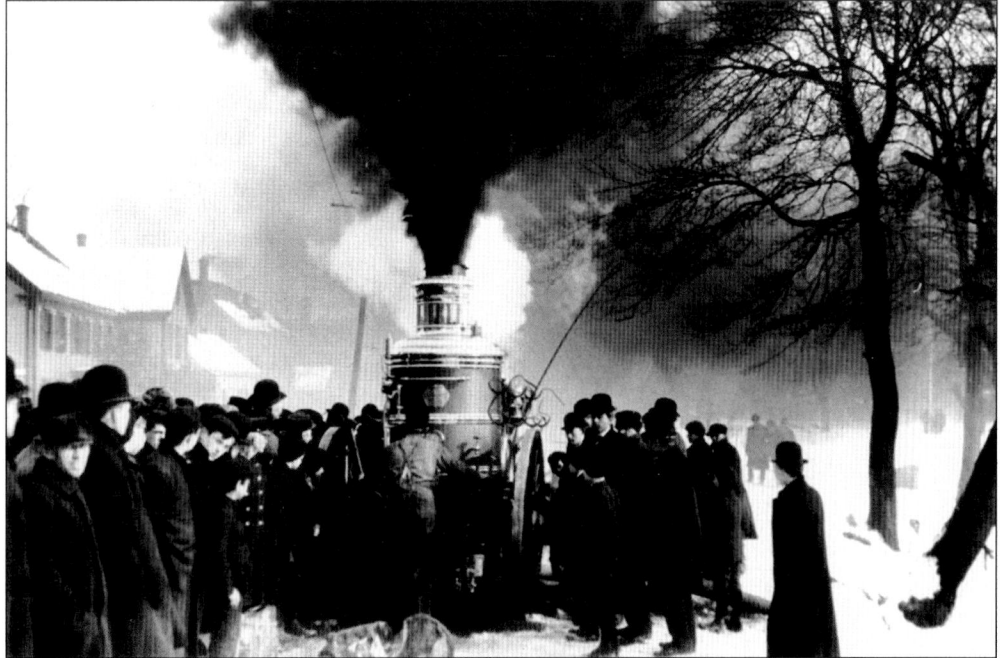

Engine 1 receives delivery of the new Amoskeag steam engine, subjecting it to testing on Chambers Street, opposite the firehouse, on February 7, 1908. (Courtesy of Mike Murphy.)

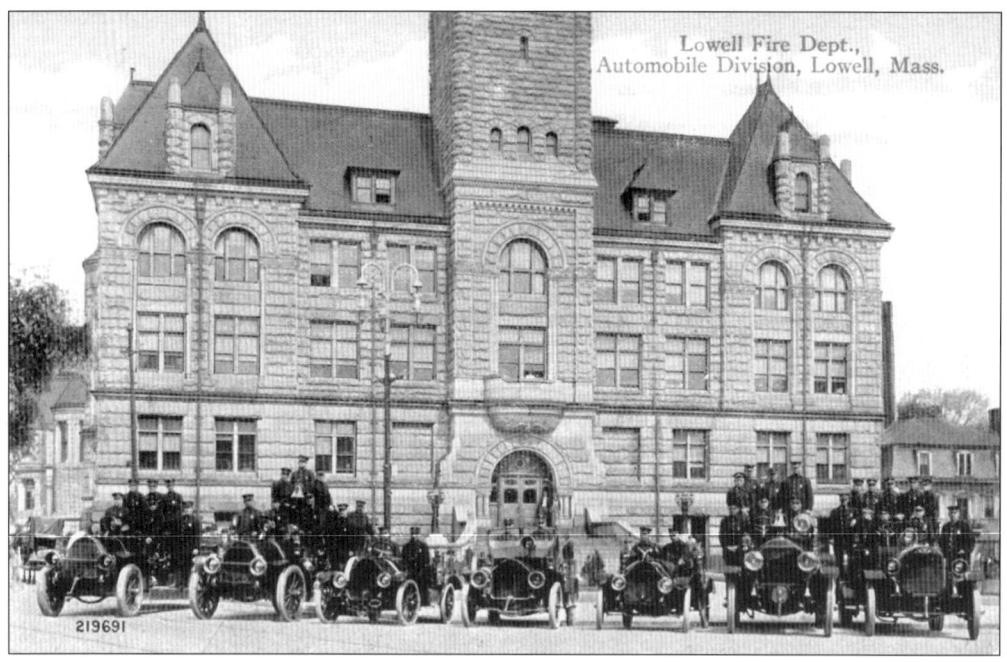

The Lowell Fire Department's flying squadron stands in front of city hall in 1913. Purchased with funding from a special appropriation, the apparatus consisted of two Knox automobiles, one at Engine 4 and one at the Protective, a Seagrave model for Engine 2, a Robinson model for Engine 8 and three chief's cars. (Author's collection.)

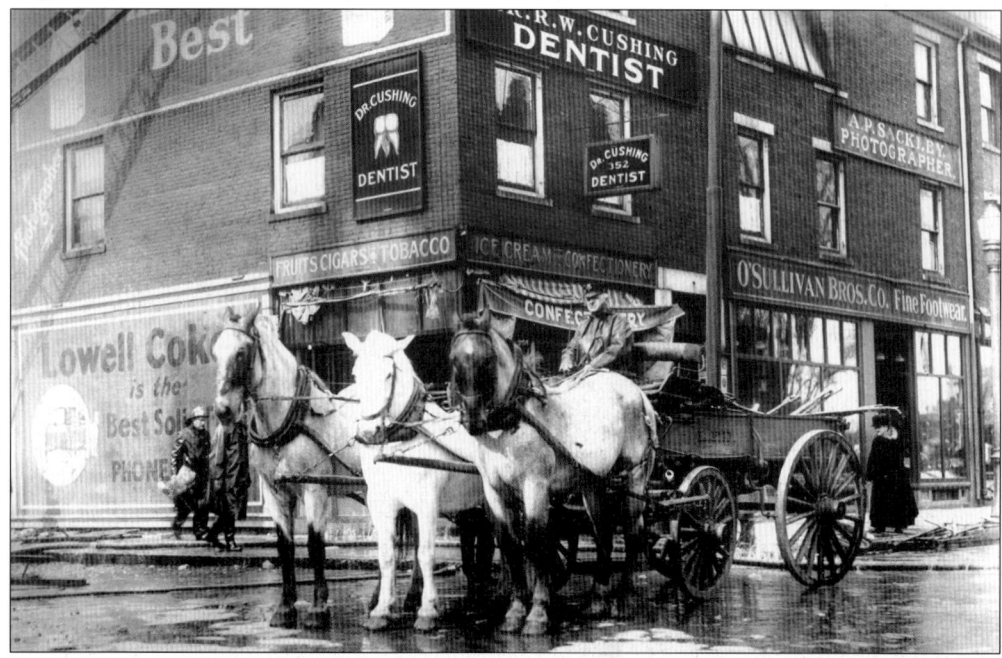

A horse-drawn hose wagon is shown at the scene of the Associates Fire on Merrimack Street in 1924. The first fire department–owned horses are listed in the 1866 chief engineer's report. From there, horse use steadily increased, peaking with 64 horses at the start of the 20th century. The last horse-drawn apparatus responded on February 15, 1925. (Courtesy of Guy Lefebvre.)

# Two

# FACES

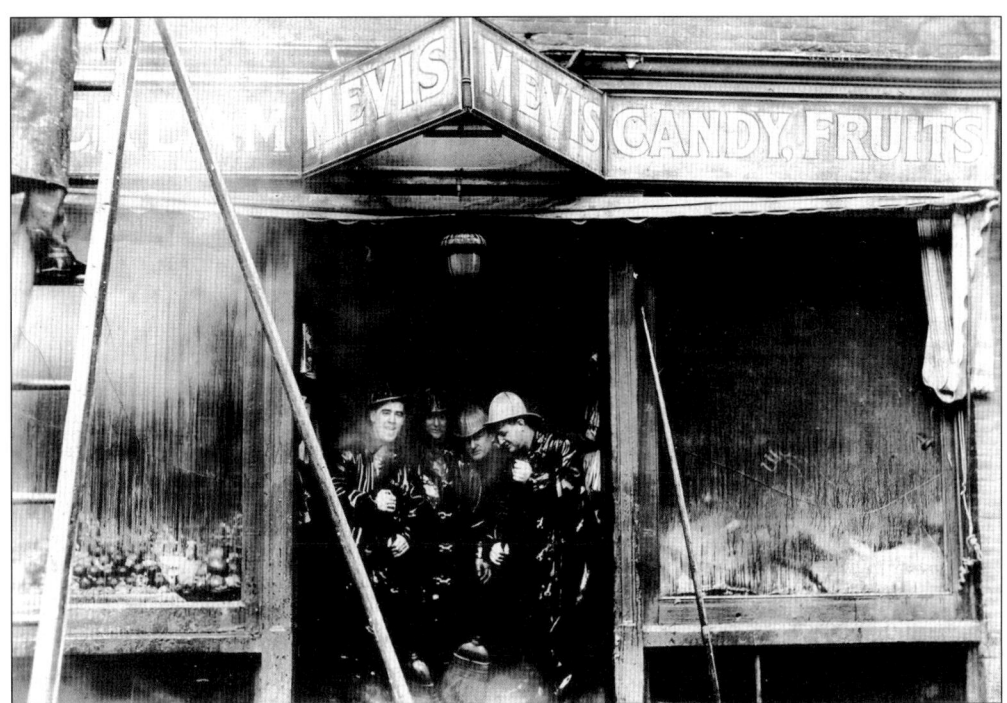

Firemen pose for the camera with their brooms during salvage operations at the Mevis Fruit Store fire on Bridge Street, February 22, 1922. (Courtesy of Dorothy Gardner-Casey.)

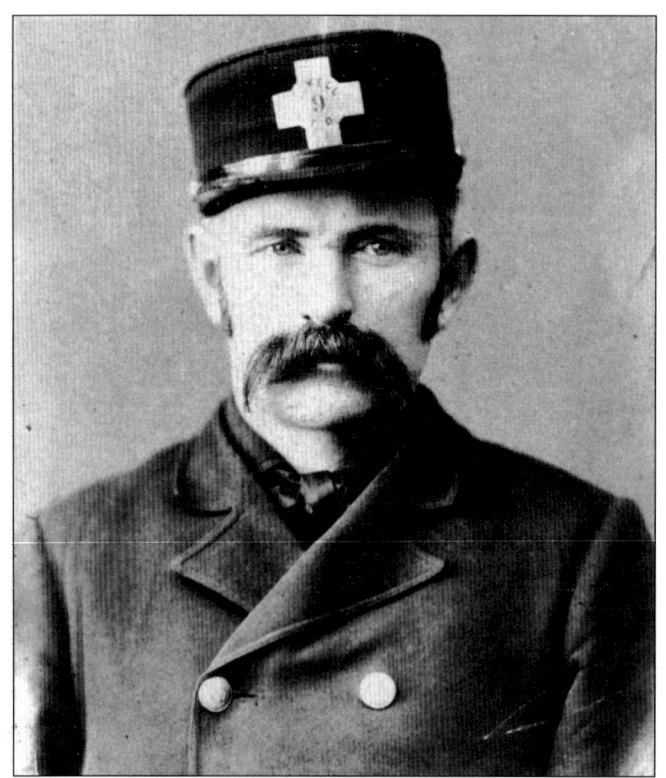

A Civil War veteran, George Whitney was one of the department's first permanent men, driving Steam Engine Company 3 beginning in 1871. Whitney was placed in charge of the city's fire alarm system in 1872 and oversaw the system until his death on December 11, 1895. Well known among local fire departments, a large delegation attended his funeral. (Courtesy of Shawn Jasper.)

Capt. Jerry Flagg of the Protective Company is shown around 1895. He joined the department in 1855. Upon his death as one of the oldest department members, on May 1, 1904, Chief Hosmer noted, "Everybody knew Jerry as one of the most honest and faithful firemen; he will be missed for a long time." (Courtesy of LHS.)

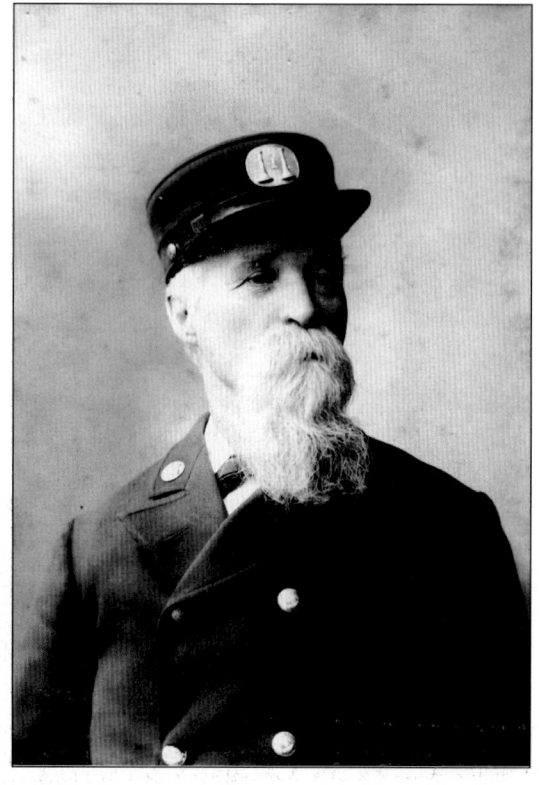

James C. Sullivan is shown at age 25 upon his appointment as a call fireman on January 1, 1893. Sullivan would rise steadily through the ranks and later be elected to the position fire chief on February 7, 1928. Sullivan retired on pension June 30, 1939, after 46 years in the department. His great-grandson Lt. John Sullivan currently serves on the department. (Courtesy of John Sullivan.)

Chief Edward F. Saunders is pictured around 1890, when he was appointed a call fireman. The municipal council elected Saunders chief of department on April 22, 1913. Saunders worked as a baker before becoming a permanent member of the department. He served as chief until 1928, spending nearly 40 years associated with the department. (Courtesy of Patrick McCabe Jr.)

Capt. Daniel Hilliard of Ladder 2 joined the department at age 21 on August 16, 1872. A captain for 37 years, he left the department on May 14, 1929, due to illness. He was the oldest member of the department when pensioned at age 78. He died only three months later. Members of the Branch Street and Gorham Street firehouses stood at attention when his funeral procession passed. (Courtesy of Ray Hilliard.)

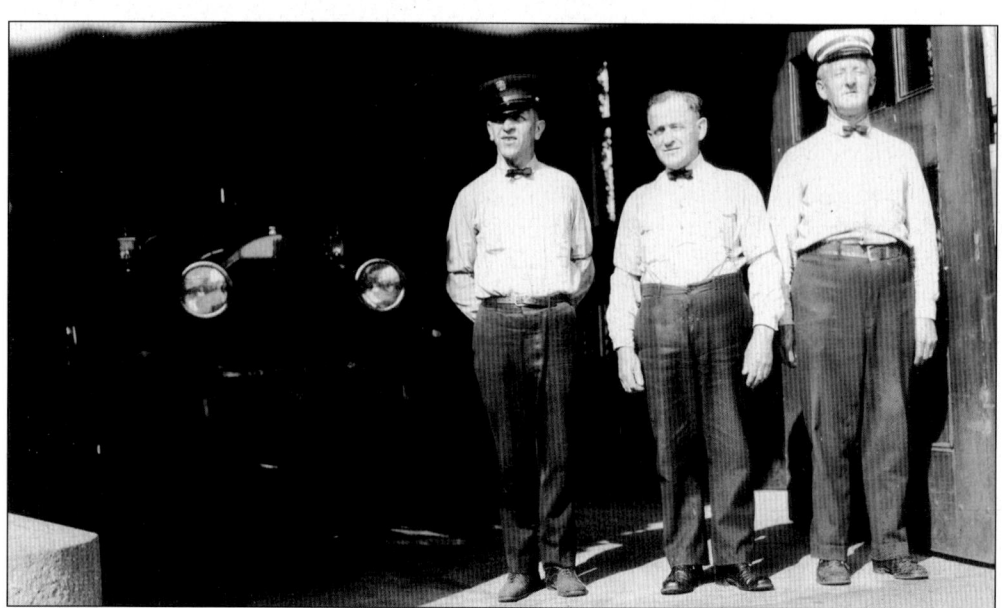

From left to right, hosemen Peter Deschene and Ed Landry pose with Lt. Lewis Reed in front of Hose Company 12 at the West Sixth Street firehouse. The station was dedicated in Deschene's memory in 1993. (Courtesy of Gerald Deschene.)

Capt. Edward Cunningham of Engine Company 6 was killed in the line of duty on April 27, 1924, at the Associates Building fire after the Worthen Street wall collapsed, crushing Ladder 4. Cunningham was working from the ladder and was thrown to the ground, crushed by the falling debris. Fireman John Gray, who was strapped in at the top of the ladder, survived the collapse. Captain Cunningham, a 15-year veteran, was commended twice for his conduct at fires. He was 41 years old and left behind a wife and family. (Courtesy of Dorothy Gardner-Casey.)

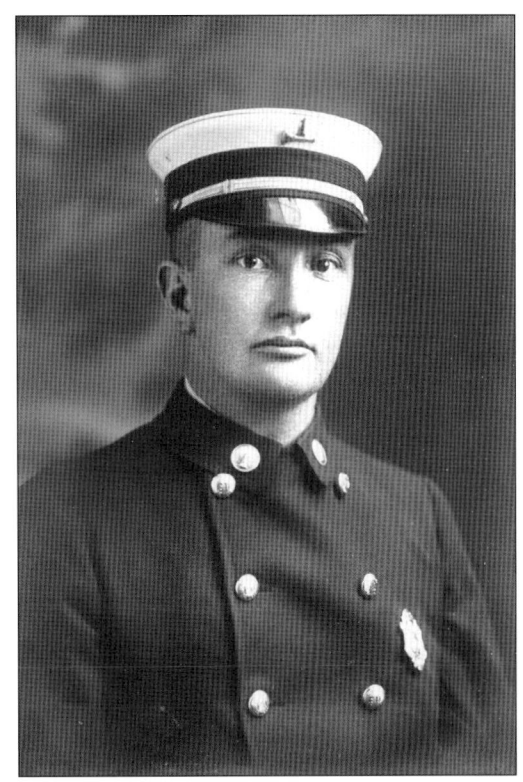

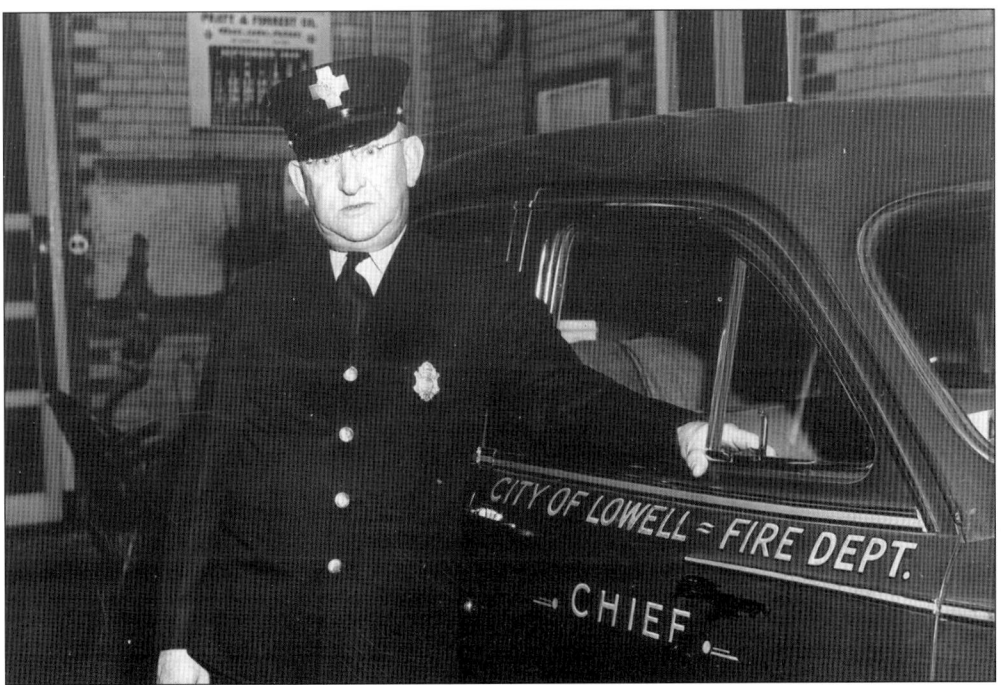

John W. Gray, survivor of the Associates Building collapse, is shown as the chief's chauffeur in the quarters of Engine 7 in 1949. Gray reportedly drove Chief Sullivan to assist at a major fire in Nashua, New Hampshire, in 11 minutes on May 5, 1930. (Courtesy of Dorothy Gardner-Casey.)

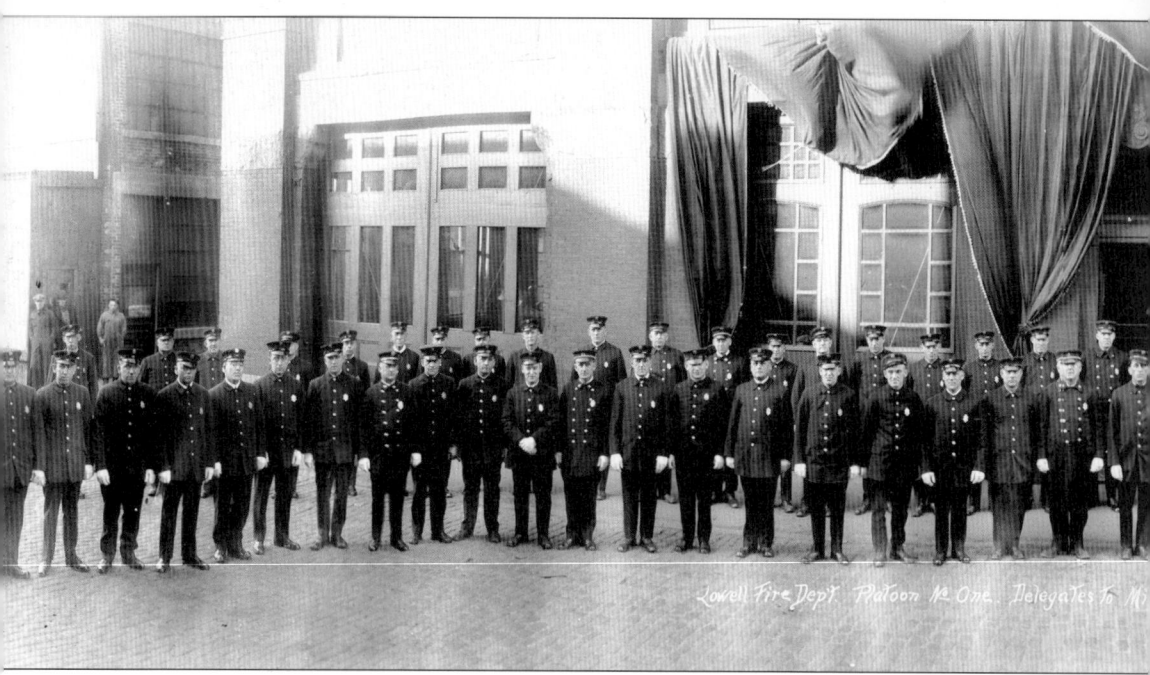

Platoon 1 of the Lowell Fire Department is pictured outside the Palmer Street Station on February 2, 1927, for the funeral of patrolman Michael Miskell of the Protective Company. Miskell died from a skull fracture received operating at Box 223 on January 30 for a fire in the Lowell Waste Company at 705 Gorham Street. Patrolman Miskell fell through an open trap

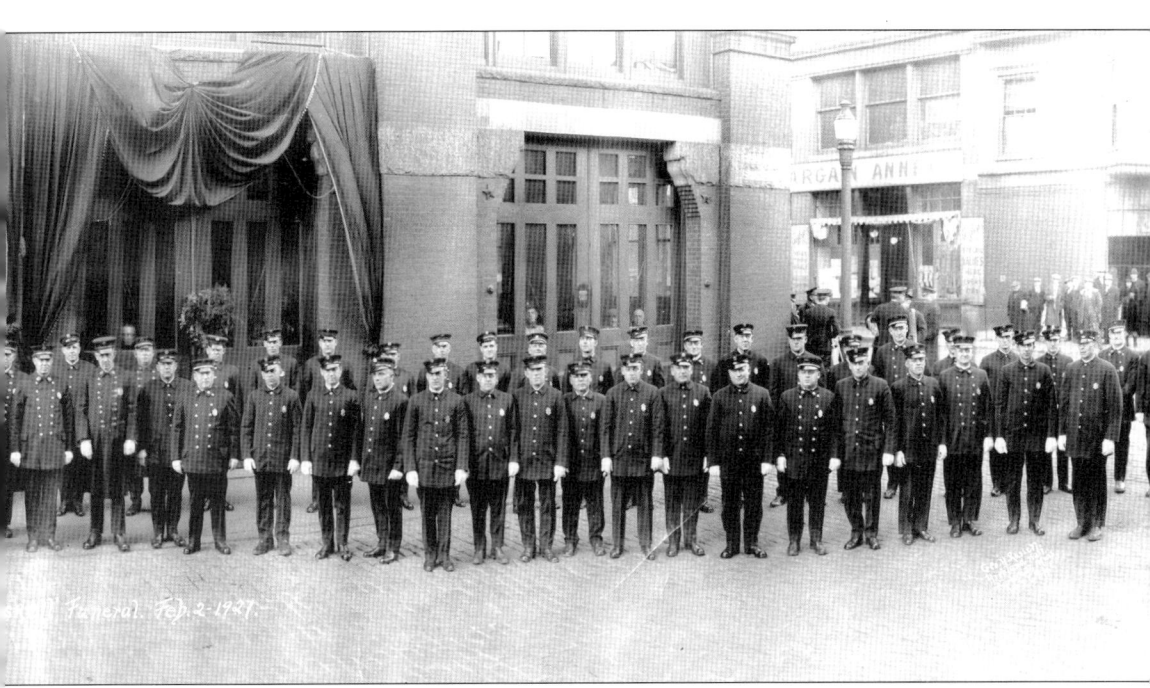

door to the basement in the darkness. Michael Gildea also fell through the door, but survived with only minor injuries. Off-duty members of the department and all members of the Protective attended the funeral.

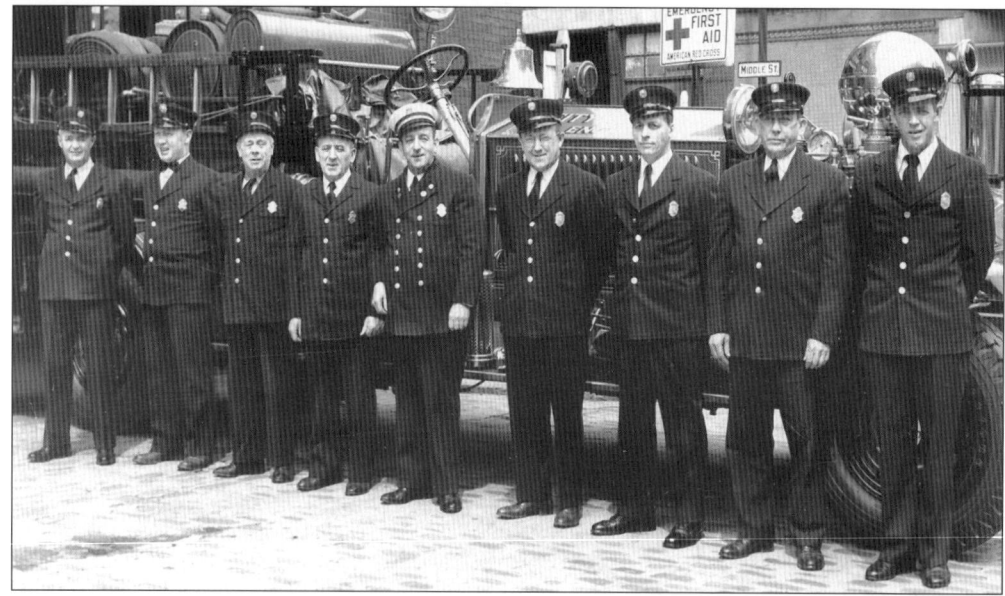

The members of Engine 3 are pictured in front of their quarters on Palmer Street in 1951, as part of the *Lowell Sun*'s "Who's Who in the Fire Department" series. From left to right are Desmond McElholm, Gerald Clark, Harry Young, Walter Powers, Capt. J. H. Lemire, Francis McCabe, Emile Wesson, Arthur J. Higgins, and John Peaslee. Harry Young would die in the line of duty, collapsing while fighting the Eliot Union Church fire July 26 of the same year. (Courtesy of Patrick McCabe Jr.)

The two-platoon system went into effect on February 4, 1920, making all members of the force permanent and cutting the workweek from 144 hours to 84 hours, allowing firemen to see their families more often. The eight surviving members appointed by Fire Commissioner Jon Salmon at the start of the two-platoon system are shown around 1950. From left to right are (first row) Archie E. Kenefick, William F. Riley, Chief Francis J. Kelleher, and William Graham; (second row) William A. Corbett, Paul A. Johnston, Clarence E. Gillis, and Frank Geary. (Courtesy of the Sun of Lowell.)

Arthur Diette sits at the watch desk of Engine Company 7 in the Highlands. Many people, young and old, referred to as "house sitters" or "sparks," frequented their neighborhood firehouses to spend time with the firemen and follow them to calls. Diette went on to become a sergeant in the Lowell Police Department. (Courtesy of Patrick McCabe Jr.)

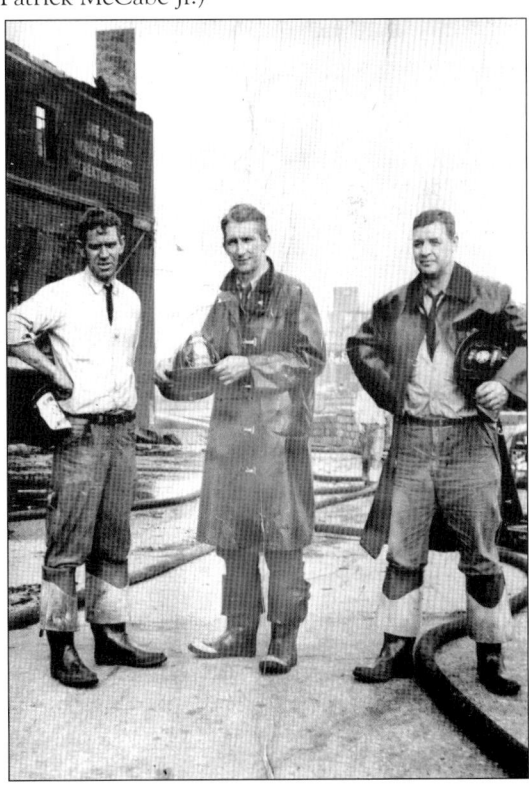

Lt. Frank Donnelly (left), firemen Thomas Rogers (center), and Lou Chaisson stand outside the ruins of the Rex fire on June 26, 1960. Part of the uniform requirement was the ties, which they wore even under their rubber gear. (Courtesy of Tom Rogers Jr.)

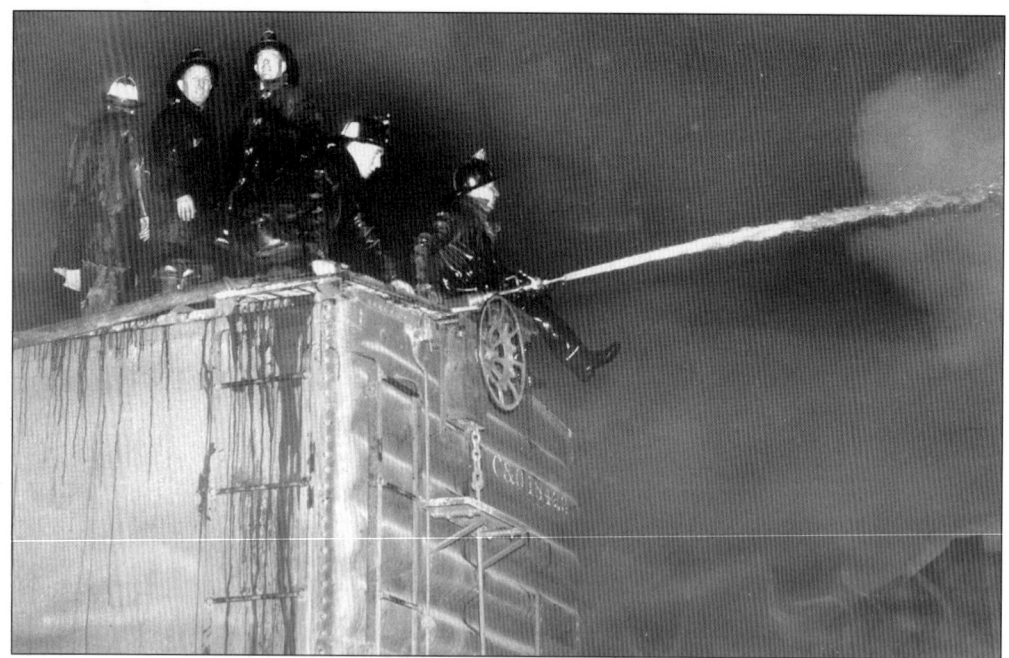

Perched atop a railcar are members of Engines 2 and 3. From left to right are Lt. Robert Lemire, Gerry Lavallee, George Rogers, Harold Demange, and Ernie Gelleneau. The fire occurred at the Lowell Corrugated Container Corporation on Bolt Street and caused an estimated $750,000 in damage in 1963. (Courtesy of the Sun of Lowell, photograph by Gerald Lavallee.)

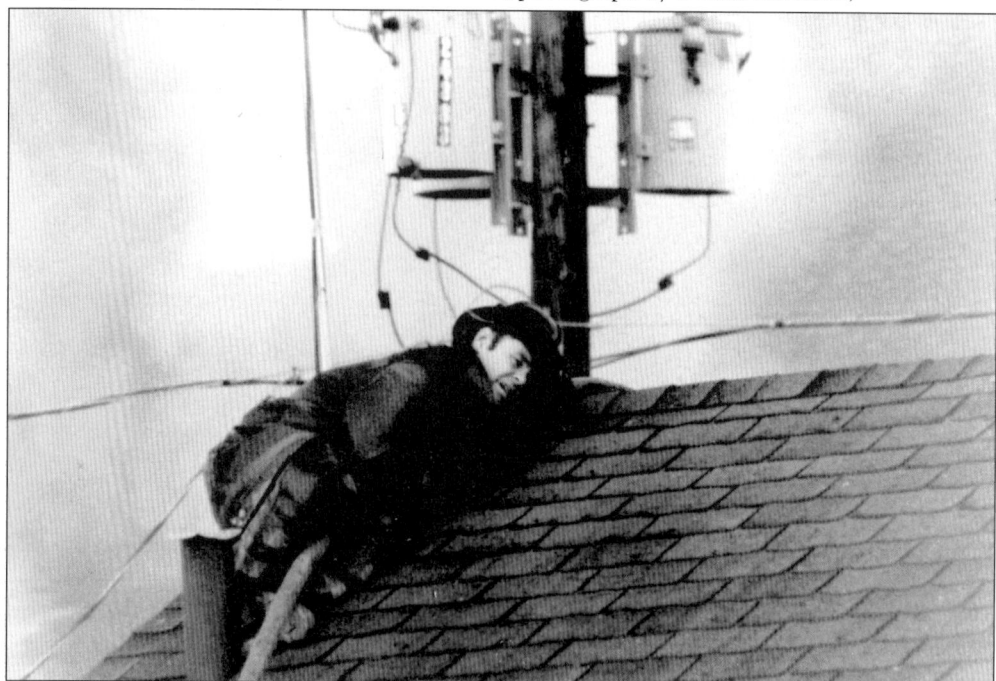

With electric lines and transformers a few feet over his head, firefighter Michael Murphy uses a hose line to protect the exposed side of a home facing the intense radiant heat of the Perry Street mill fire in 1978. (Courtesy of Michael Murphy.)

Firefighter Paul "Skip" Arguin of Engine Company 4 trains a large hand line on a Middlesex Street fire occurring on June 22, 1978, assisted by Lt. Joe Kubit. Capt. Edmund O'Connor is visible in the background carrying a ground ladder. (Courtesy of the Sun of Lowell.)

Firefighter Fred Evici prepares to advance a hose line through the smoke into a second-floor apartment fire on Salem Street in the Acre on March 17, 1980. (Courtesy of the Sun of Lowell, photograph by Michael Pigeon.)

Fire Chief John Mulligan emerges from the scene of Lowell's deadliest fire on record at 34–36 Decatur Street on March 5, 1982. The arson fire claimed eight lives, including five children. Mulligan served as chief from 1977 to 1987, supervising the department through some of Lowell's largest and deadliest fires. (Courtesy of the Sun of Lowell, photograph by Richard Hunt.)

Firefighters Bill Watson (left front) and Bob Carroll (right front) assist funeral director John McDonough in the grim task of removing the body of a fire victim on Stackpole Street in 1988. Although death from buns due to fire has decreased, the smoke produced by the burning of synthetic products is more deadly than ever. (Courtesy of the Sun of Lowell.)

A fire at 65–69 Pine Street on March 11, 1985, left five families homeless. Ray Keefe (left) and Norman Nadeau (center) emerge from battling through the heavy smoke to the aerial ladder placed at a window. Firefighter Dave McAleer is working from the ladder with a pike pole. (Courtesy of the Sun of Lowell.)

The members of Engine Company 2 pose with their apparatus outside quarters in 1985. From left to right are Capt. Patrick McCabe Jr., Lt. Thomas Hill, Lt. Thomas Linnehan, and firefighters David Hunt, Dana Price, Michael Janeiro, Thomas Rogers, Paul Clark, and Thomas Dowling. (Courtesy of Sean Ready.)

Lt. Ted Nunes emerges covered in soot and ash at the scene of a four-alarm tenement fire located at 25 Union Street. The fire broke out at 1:15 p.m. on April 5, 1988, and left 50 homeless. (Courtesy of the Sun of Lowell.)

Exhausted firefighters rest after many rescues were made at a rooming house fire on Appleton Street on July 31, 1991. From left to right are Stanley Trzcienski, Ramon Rodriguez, Capt. Mike Murphy, James Doster, and Larry Finn. Kneeling are William Ryan and Lt Richard Levasseur. (Courtesy of the Sun of Lowell.)

## Three

# FIREHOUSES

Land was purchased in the fall of 1874 on Gorham Street just above Congress Street, and plans went before the committee on the fire department for a new engine house. In December 1875, Steam Engine Company 1 transferred to the new Gorham Street house. The cost of the building, including the bell and striker, totaled $11,000. (Courtesy of Robert Doyle.)

The Gorham Street firehouse is shown in the 1960s. The station was expanded to three apparatus bays before the arrival of the steam engine purchased in 1908, and the detailed wood moldings and ornate roof were lost. The station was refurbished by the Work Projects Administration between 1939 and 1940. It still houses Engine Company 1 today, along with the on-duty deputy chief of car 3. (Courtesy of Robert Washburn.)

In 1878, the chief engineer's report describes a "substantial building" erected in 1877 on Branch Street, furnishing accommodations for a wardroom and the apparatus located in that part of the city. The Torrent firehouse quartered Steam Fire Engine Company 2 and its hose carriage. The apparatus was previously housed on Middlesex Street. (Courtesy of the Sun of Lowell, photograph by Robert Wallace.)

Although originally built to house a two-piece engine company, Engine 2 and Ladder 2 began to share quarters after the closure of the Westford Street station in the early 1920s. The two companies have responded together for over 80 years. (Courtesy of Robert Washburn.)

Engine Company 2's Maxim pumper stands ready outside the garage bay in 1973. The nearly 100-year-old station began to show its signs of age, and the Torrent sign disappeared. In the 1990s, an extensive restoration took place at a cost of $360,000, and on May 17, 1997, the station was cited by Massachusetts secretary of state William Galvin as an example of historical preservation. Today the station appears much as it did when built. (Courtesy of Michael Murphy.)

This firehouse was built at 29 Fourth Street in 1879 for the Centralville neighborhood. The building first served as home to Wellman Hose Company 5. Over the life of the building as an active fire station, Fourth Street was home to Hose 10, Ladder 1, Ladder 4, Engine 5, and Engine 6. (Courtesy of Robert Doyle.)

Engine 5's house is shown as it appeared when closed on April 17, 1992, after over 110 years of service in Centralville and Christian Hill. The hayloft doors are still visible in the upper left corner of the building. Although still standing, the building is no longer under control of the fire department. (Courtesy of the Sun of Lowell.)

Built in 1881, the Fletcher Street firehouse was located on the corner of West Clark Street next to the North Common. The building became the new home of Mechanic's Hose Company 7 and furnished accommodations for a wardroom. In 1892, Hose 7 moved to Central Street and Steam Engine 6 was established in the station. Closed in 1937, it now is home to the Lafayette Club. (Courtesy of Robert Doyle.)

A new house was contracted for Hose Company 6, with construction beginning in 1886. Located on the corner of Central and North Streets, the station was ready for use by March 1887. The building also underwent a substantial renovation in 1910. Over the course of its life, this Central Street firehouse was also home to Hose 7 and Hose 13. It closed on October 2, 1936, as the quarters of Engine Company 13. The Pulaski Club occupies the building today. (Courtesy of Robert Doyle.)

In 1887, a new house was built for Protective Company 1 on Warren Street. It was considered "a model house, well adapted to the purpose it served." The building was converted for use by a motorized apparatus in 1910 but was abandoned by the department shortly before 1920. The station stood near what is now the service entrance to the hotel on Warren Street. (Courtesy of Robert Doyle.)

Selected by the city because the elevated location provided easier access to cover multiple neighborhoods and businesses, area residents complained the new firehouse at Westford and Lane Streets would depreciate their property values. In addition to the noise concerns, residents reportedly told Chief Norton that firemen sitting outside the engine house in their shirt sleeves would not look good. Nonetheless, construction began in 1888 on the double house in the Highlands. Opened in 1889, Ladder Company 2 and Chemical Engine C were the only companies to occupy the building over its time as a firehouse. Today it is a church hall. (Courtesy of Robert Doyle.)

Mazeppa Engine Company 4 opened in 1889. The brick station was built to replace the wood frame hose company house at the corner of Chestnut and Fayette Streets. A first size Amoskeag steam engine was purchased for the house bearing the name for Ivan Stepanovich Mazeppa, a 17th-century Polish-born Cossack noted for his horsemanship and cavalry charges. (Author's collection.)

Engine Company 4 members and their apparatus are pictured around 1915. The company received its first motorized apparatus, a Knox model combination chemical and hose wagon, in December 1912. Although the ivy no longer grows on the exterior, the historic facade has been restored. Engine 4 has responded to first alarms in Belvidere and downtown Lowell for over 110 years. (Courtesy of Paul Cronk.)

Members of Palmer Street Fire Headquarters posing with their apparatus in 1952, from left to right, are Stan Shaw, Frank Hogan, Lt. Howe, Chief Kelleher, an unidentified civilian, John Daly, Connie Finnegan, Don Carroll, and Mike Netishen. The fire department still provided ambulance service to the city, the ambulance visible at far right. (Courtesy of Joseph Mahoney.)

In 1883, Lamson Hand Hose Company 9, consisting of 10 call men, organized in Ayers City under rules and regulations of the department. Initially the company only responded to alarms in their vicinity except in the event of a general alarm. On November 1, 1890, a company of six men, including two permanent firemen, was organized with a one-horse hose wagon. The new wood frame firehouse was built on city-owned land at what is now the corner of Eaton and Lincoln Streets. Hose Company 14 was the last company to operate from the station, which closed on October 2, 1936. (Courtesy of Robert Doyle.)

In 1889, the city purchased the land on Lawrence Street for a new firehouse. Construction began in 1891, and apparatus was purchased for Hose Company 11 in 1892. Ladder Company 1 would be moved to join the newly established hose company in the double house. (Courtesy of Robert Doyle.)

The Lawrence Street firehouse is pictured in the late 1970s. Hose 11 became Engine 11 after the closing of Engine 13 on Central Street in 1936. Although the apparatus bay doors would later need to be widened to accommodate larger apparatus, the building appears much the same as it has for the last century. This firehouse was also the original home of the Lowell Firefighters Credit Union, which had an office on the second floor of the ladder company side of the building. (Courtesy of the Sun of Lowell, photograph by Michael Pigeon.)

Constructed and established simultaneously with the Lawrence Street station was the new Pawtucketville Firehouse on Mammoth Road. The station is pictured with one of the company's horse exercise wagons, photographed for the 1899 chief engineer's report. Engine Company 5, built by the American Fire Engine Company of Seneca Falls, New York, at a cost of $3,300, was placed in service at the station. (Courtesy of Robert Doyle.)

Shown in 1971, the Mammoth Road firehouse was then home to Engine Company 10. Engine 8 would join the house with the closure of its Race Street quarters two years later. Both engines responded from the same house until Engine 10 relocated with the opening of the new Old Ferry Road station in 1977. In October 1987, the station was dedicated to the memory of firefighter John Barry Gannon, who died in the line of duty on August 7, 1986. (Courtesy of the Sun of Lowell, photograph by Richard Hunt.)

Firefighters pose in the Mammoth Road station (Engine 8) one last time on April 17, 1992, as the city permanently closes the firehouses of Engines 5, 8, and 9. A total of 34 firefighters were laid off as a result, deeply cutting the department's numbers and morale. Pictured from left to right are (first row) Lt. Ted Nunes, Ed Pepin, Mark Boldrighini, Al Stamp, Dennis Baribeault, Capt. Bill Kilbride, and Dennis Bergeron; (second row) Joe D'Amboise, Anthony Stairs, Fred Demers, Kevin Burgoyne, and Deputy Chief Gerald Roth. The station served as an active firehouse from 1892 to 1992. It now houses the Fire Prevention Bureau. (Courtesy of the Sun of Lowell.)

A former schoolhouse located at the corner of Merrimack and Race Streets was remodeled to house a chemical engine and three permanent men in 1885. It later was converted to Hose Company 8 on February 24, 1890. Although facing Merrimack Street, the station, when converted for fire department use, was referred to as the Race Street Engine House. To this day, that designation has stuck. (Courtesy of Robert Doyle.)

In 1910, Hose Company 8's original house was torn down and a new station, which opened early in January 1911, was built. The total cost of construction was $5,833.07. Engine 8's house, shown here in the summer of 1971, operated from this location until the opening of the JFK Civic Center Firehouse in 1972. Engine 8 was then moved to the Mammoth Road firehouse to supplement coverage of the growing Pawtucketville neighborhood. (Courtesy of the Sun of Lowell, photograph by Richard Hunt.)

People watch from the Race Street side as Engine 8's house meets the wrecking ball after the station closed. The section of Race Street, adjacent to what is now Archambeault Towers, no longer runs through to Merrimack Street. The firehouse is one of the few closed firehouses not to be reused after its time of service ended. (Courtesy of the Sun of Lowell.)

In 1908, Hose Company 12 was established at 284 West Sixth Street under Capt. H. A. Merrill. Truck Company 4 was moved into the same quarters. The station had six sleeping rooms on the hose side and eight more on the truck side. The 65-foot-high tower, 11.5 feet square, held a 500-pound bell, which still remains. In 1927, the tower was made into a drill tower for less than $1,000. A smokehouse was later constructed in the basement. Capt. George A. Campbell, a graduate of the Boston Fire Department Drill School, began carrying out a prescribed schedule of company drills with the tower during good weather. (Courtesy of Gerald Deschene.)

Engine Company 6 moved from Fletcher Street to temporary quarters with Engine 5 on Fourth Street in 1937, due to bridge closings limiting access to Centralville. The change provided a full first alarm of apparatus on the north side of the Merrimack River, with only the Protective Company needing to cross a bridge in the event of a fire. A short time later, Engine 6 moved to new permanent quarters with Ladder Company 4 on West Sixth Street. Hose 12 was disbanded at that time, the last hose company to operate in the city. The West Sixth Street station was dedicated in 1993 to Peter Deschene, who served in the department from 1921 to 1960. (Author's collection.)

Engine Company 7 stands at the corner of Stevens and Pine Streets in the Highlands section of Lowell. The bungalow-style firehouse with stucco exterior and tile roof was opened on December 30, 1921. The first station in the city built for a motorized piece of apparatus, it was described as "modern in every way and fully equipped," with a White triple combination engine. (Courtesy of Robert Washburn.)

Engine Company 7's quarters were dedicated on October 26, 1992, to the memory of Lt. William P. McCarthy, who served in the department from August 4, 1946, to January 15, 1973. Lieutenant McCarthy served 14 consecutive terms as secretary-treasurer of the Professional Firefighters of Massachusetts. In the late 1990s, the two bay doors were removed to make way for a single door, necessitated by the new, larger apparatus. (Courtesy of John Kelley.)

Members pose outside Engine 9's quarters in 1939. From left to right are George Nickerson, Hugh Finnerty, Peter Regan, James Tracy, John Quinn, and Lt. Daniel Murphy. Regan is holding his dog, appropriately named Sparky. (Courtesy of Dorothy Gardner-Casey.)

Engine Company 9 opened on November 7, 1924, at the corner of Rogers and Fairmount Streets in the Oaklands section of the city. A bungalow-style firehouse similar to Engine 7, it featured a drive-though apparatus bay, the first of its type in the city. The station closed as an active fire company in 1992, after 68 years of service. Today it serves as the department's training and public education facility. (Courtesy of Robert Washburn.)

The new fire headquarters at the John F. Kennedy Civic Center opened on January 20, 1973. Both the Palmer Street and Race Street locations were closed at that time. Engine 3, Ladder 3, Rescue 1, and Car 2 respond to the downtown and Acre sections from this station. The North Canal Housing Development is under construction in the background. (Courtesy of Gerald Lavallee.)

Engine 10's new house on Old Ferry Road opened on April 29, 1977. The station is dedicated to the memory of Deputy Chief Thomas J. Burke, the first department member to receive the honor. Built by McLeod Construction with funds from the Community Development Block Grant Program, the station cost $194,733. (Courtesy of John Kelley.)

## Four

# FIRE APPARATUS

Placed in service with the Protective Company on April 2, 1910, the Knox automobile patrol wagon was Lowell's first piece of motorized fire apparatus. The automobile and crew are outside their Warren Street quarters, which underwent a substantial renovation to accommodate the new apparatus. (Courtesy of Thomas Brothers.)

Fire chief's chauffeur John Gray sits behind the wheel of an early chief's car in front of the Fletcher Street firehouse in the 1920s. The chief's car and drivers were usually stationed in the firehouse closest to where he resided. (Courtesy of Dorothy Gardner-Casey.)

Engine Company 2's Seagrave chemical hose wagon manufactured in Columbus, Ohio, stands inside its quarters after entering service in February 1913. Part of the city's Flying Squadron, the new apparatus reached cruising speeds of 35 miles per hour on its test drive, was able to handle the climbs up Belvidere and Christian Hills, and weighed in at 8,650 pounds. (Courtesy of Robert Doyle.)

Assistant Chief Richard Burns poses with his driver and new automobile outside the Race Street station in 1928. (Courtesy of Dorothy Gardner-Casey.)

The crew members of Ladder Company 4 pose for a picture with their apparatus in front of their West Sixth Street quarters. The city service model White ladder truck began service in 1924, after an emergency appropriation was made to replace equipment damaged at the Associates Building fire. (Courtesy of Brian Callahan.)

Ladder 4 is involved in a crash with Hose Company 13 at the corner of Broadway and Suffolk Streets on September 4, 1925. Six members of the company were aboard when the accident occurred, sending the truck into the Western Canal. Miraculously, five laddermen sustained only minor injuries in the accident, responding to an alarm found to be only a malfunction. It took three hours to raise the truck, lifting with a steam shovel and pulling with two Mack trucks. (Courtesy of Dorothy Gardner-Casey.)

Engine Company 3 poses with its new Ahrens-Fox engine, purchased in 1930 at a cost of $13,481.81. The engine had a pump capacity of 1,000 gallons per minute. (Courtesy of Dorothy Gardner-Casey.)

This 1936 Seagrave model 85-foot, tractor-drawn ladder truck operated from the Palmer Street station as Ladder Company 3. The truck cost $17,000 and featured a steel aerial ladder. Upon arrival in 1937, department members demonstrated the truck by raising the ladder and climbing up the exterior of city hall. (Courtesy of George Porier.)

Fireman Ralph Carnevale sits behind the wheel of a 1924 white 600-gallon-per-minute engine still in service as Engine 9 in 1944. The engine carried brass pump cans for brush fires, kerosene lanterns for lighting fire scenes, and had a canvas windshield. (Courtesy of Ralph Carnevale.)

Engine 10's 1943 Seagrave 750-gallon-per-minute engine is shown outside its Mammoth Road quarters in 1963. Engine 10 members Peter J. O'Rourke and Joseph A. Sheehy died in the line of duty as a result of injuries sustained in an apparatus accident. The engine lost control, striking a utility pole and crashing into a barn while responding to a chimney fire at 1522 Varnum Avenue on June 18, 1943. (Courtesy of George Porier.)

Ladder 2 stands by at the scene of a small fire on Pine Street in the 1960s. The truck is a 65-foot, 1947 Seagrave junior aerial ladder. (Courtesy of Robert Washburn.)

Engine 6 operated this 1948 American LaFrance open-cab engine for nearly 30 years. The 750-gallon-per-minute engine responded until it was replaced in September 1976. At one time, the city ran four of this style engines. The other models were located at engines 7, 9, and 11. (Courtesy of George Porier.)

Ladder 1's 1948 American LaFrance aerial ladder stands across from its Lawrence Street quarters in 1963. The first aerial ladder for the company, this truck would see front line service until replaced in 1981. The Perry Street Mills are visible in the distance at far right. (Courtesy of George Porier.)

Two new trucks are tested using elevated hose lines attached to their ladders on June 2, 1949. The 1948 American LaFrance 65-foot aerial ladders cost $25,000 each. One of the trucks was assigned to Ladder 1 on Lawrence Street, replacing a 28-year-old city service model. The other was assigned to Ladder 4 on West Sixth Street. (Courtesy of Bill Daly.)

Engine Company 3's 1956 B model Mack stands outside its quarters in the early 1960s. The engine featured a 750-gallon-per-minute pump, a 300-gallon booster tank of water, and one of the first enclosed cabs in the city. The same engine would later serve as Engine 5. (Courtesy of George Porier.)

64

Shown parked at a fire scene in 1958 is the fire chief's Mercury Monterey sedan. (Courtesy of Robert Doyle.)

Engine 2's 1958 B model Mack pumps at a fire in the Highlands neighborhood in the 1960s. The engine featured a 1,000-gallon-per-minute pump, a 300-gallon water tank, and later served as Engine 1. As apparatus engines became more powerful, it allowed more powerful pumps and the capacity to carry the extra weight of water aboard. This improvement allowed fires to be attacked immediately, without connecting to a hydrant. (Courtesy of Robert Washburn.)

Rescue Company 1's 1957 GMC truck is pictured outside its quarters on Palmer Street in 1963. Purchased at a cost of $10,703.71, it was the first closed-cab, van-style rescue truck in the city. The rear box portion would be refitted to another chassis in 1973. (Courtesy of George Porier.)

Standing by on Fletcher Street is Engine 8's 1,000-gallon-per-minute C model Mack. Purchased at a cost of $28,000, it went into service the first week of March 1963 under command of Capt. Patrick McCabe. (Courtesy of Robert Washburn.)

Engine 4's C model Mack cost $26,980 when purchased in January 1966. Pictured on Market Street shortly after it was delivered, it replaced a 1940 engine at the High Street station. (Author's collection.)

Ladder 2's 1967 Mack C95 model tractor and Maxim 100-foot trailer are photographed outside the trailer lunch stand on October 7, 1986. (Courtesy of Mark Roche.)

Engine Company 3's 1972 Mack CF model engine is pictured on Moody Street outside the Civic Center firehouse. The engine featuring a 500-gallon tank and 1,000-gallon-per-minute pump was in service until the early 1990s. (Courtesy of Frank Kelly Jr.)

Engine 2's 1973 Maxim Motors Apparatus featured a 1,000-gallon-per-minute pump and 500-gallon tank. This was the first automatic transmission fire apparatus the city ever purchased. It was also one of the last apparatus in service where firefighters rode the back step of the engine to calls. (Courtesy of Bill Daly.)

The last new apparatus purchased for the Oakland Fire Station was this 1977 Ward LaFrance Engine with a 1,250-gallon-per-minute pump and a 500-gallon water tank. (Courtesy of the Sun of Lowell, photograph by Michael Pigeon.)

From left to right, firefighter John Diaz, firefighter John B. Gannon, and Capt. Jim Sheehan are pictured on March 19, 1980, with the brush fire truck stationed at Engine 10's Old Ferry Road firehouse. The former military truck was converted by department mechanic Bill Dempsey and used to battle fires in the local state forest after state forest fire crews were cut back. (Courtesy of the Sun of Lowell, photograph by David Brow.)

Nicknamed "Brutus" because of its large size when compared to the engine it replaced, Engine 7's 1980 Ford Emergency One is shown outside its quarters. The engine fit so tightly in the bay that the mirror needed to be folded in before the engine could back up. This was the first E-One apparatus purchased in Lowell. In 2006, for the first time in department history, this same company manufactured all the city's front line fire apparatus. (Courtesy of the Sun of Lowell, photograph by Richard Hunt.)

Ladder 3 sits wrecked in its garage bay at the JFK Civic Center on February 1, 1982. The truck was responding mutual aid to a four-alarm Lawrence blaze when it was involved in an accident on Riverside Drive after skidding on ice. The truck jackknifed then struck a tree and a utility pole before coming to a stop. Lt. James Nutter was thrown from the cab, sustaining hip and back injuries. Driver Lucien Latulippe sustained cuts and bruises. Tiller man Henry Lohmer was uninjured. Chief Mulligan remarked, "They were lucky to all come out alive." Unshaken, Lohmer got right back in and drove the tiller section when the truck was towed back to Lowell. (Courtesy of the Sun of Lowell, photograph by Richard Hunt.)

## Five
# Fires and Rescues

The St. Jean Baptiste Church on the corner of Merrimack and Aiken Streets burned in the early morning hours of November 21, 1912. The fire destroyed the entire church interior, leaving only the granite walls standing. The department reported a loss on the property of $110,466.50. A total of 25 firemen were treated for smoke inhalation. (Courtesy of Guy Lefevbre.)

Nearly 1,500 people, mostly high school students watching their yearly play, fled the fire at the Central Street Opera House, the afternoon of February 4, 1924. The three-alarm fire originated in a tailor shop on the first floor of the reportedly 125-year-old building, one of the oldest structures in the city at the time. (Courtesy of Dorothy Gardner-Casey.)

Firemen train their hoses down from the roofs of the J. R. Smith wood yard at the Ryan Grain Company fire located at 425 Broadway Street on April 7, 1925. Two alarms operated on the grain company, while an additional alarm responded to protect the adjacent Otis Allen Box Company at their request. It was the second fire at the grain company in a matter of weeks and left two horses burned. (Courtesy of Dorothy Gardner-Casey.)

Firefighters responded to Box 21 for a fire in the Wentworth Building at the corner of Merrimack and Shattuck Streets on June 9, 1926. It was the second general alarm fire in downtown within a week. The fire began in the basement and extended to the upper floors, causing $200,000 in damages. (Courtesy of Dorothy Gardner-Casey.)

Another view of the Wentworth Building fire from the Dutton Street side shows firefighters accessing the building through sidewalk hatches and ladders. Interesting to note is the opening in the street (at left below the light post) through which a suction hose was dropped. Lowell has access-plate hydrants located on some of its bridges over canals, allowing easy access for engines to draft water. (Courtesy of Dorothy Gardner-Casey.)

73

Traffic and trolleys are at a standstill at the intersection of Merrimack and Dutton Streets as fire hoses and apparatus block their paths during the Wentworth Building fire. Taken from an upper level of city hall, nearly every building visible in the photograph suffered at least one fire in its lifetime. The Mongeau Building at right survived its first blaze but eventually was destroyed by fire. (Courtesy of Dorothy Gardner-Casey.)

A large crowd watches heavy flames and smoke from a fire involving the textile school sheds in Pawtucketville, during March 1927. The fire is believed to have occurred in the area between what is now Riverside Street and the VFW Highway, on the campus of the University of Massachusetts at Lowell. (Courtesy of Dorothy Gardner-Casey.)

The Omaha meat packing plant on Market Street was the scene of this fire just before noon on January 6, 1943. The fire originated in the smoke room of the plant, spreading to the upper floor and trapping at least 20 workers. Workers can be seen hanging from windows awaiting rescue by ladder. Over a dozen were treated at St. John's Hospital for injuries. The dramatic shot by Dow Case of the *Lowell Sun* was awarded New England photograph of the year from the Associated Press. (Courtesy of Lt. Bill Daly.)

Onlookers gather to watch the fully involved building of the Friend lumber company on Mount Vernon Street, just after midnight on February 15, 1955. Three alarms of firefighters were needed to fight just one of many large lumberyard fires in the course of the city's history. Snow covering rooftops was credited with preventing this fire from spreading to the rest of the neighborhood. (Courtesy of Robert Doyle.)

Ladder 1's driver raises the aerial ladder at a multiple-alarm fire in a large wooden tenement located on Gorham Street, near Gallagher Square in the late 1950s. Jim Daly, brother of Lowell Fire lieutenant William Daly, is visible helping firefighters move a hose line at the large blaze. (Courtesy of Robert Doyle.)

Smoke obscures Merrimack Street looking east from the corner of Paige Street during the Solomon's fire in the early 1960s. Three of the department's aerial ladders are in operation. An arrow-shaped sign on the streetlight indicates a sign of the times, the location of a downtown fallout shelter. Many firehouses were also designated as fallout shelters. (Courtesy of Robert Doyle.)

Laddermen Leon Fontaine and Bill Winn climb the aerial ladder to advance a hose at the Sacred Heart School fire on May 6, 1967. Fireman John J. Wojtas, age 54, died in the line of duty after suffering a heart attack while raising ladders at the scene. The newer building of the school complex was destroyed, a loss estimated at $750,000. (Courtesy of the Sun of Lowell.)

An early morning fire destroys the building at 15–23 East Merrimack Street in downtown. The block contained the Board Room Cocktail Lounge, Roy's Coiffures, and 24 newly renovated apartments. A total of 22 people were left homeless, and $250,000 in damage was caused by the general alarm fire on January 11, 1970. (Courtesy of the Sun of Lowell.)

On August 12, 1972, Ray Keefe, assisted by a police officer, carries a burned child to an ambulance while giving mouth-to-mouth resuscitation. The fire occurred on the fourth floor of an apartment building on Lakeview Avenue, claiming the life of three children, including the one in the photograph. Keefe worked for New England Telephone at the time of the fire. The son of a Dracut firefighter, Keefe would later join the Lowell Fire Department and be recognized on multiple occasions as Firefighter of the Year. (Courtesy of the Sun of Lowell, photograph by Michael Pigeon.)

Firefighters straddle the ridge peak of a Smith Street home in the Highlands, attempting to cut a ventilation hole during a smoky attic fire in February 1973. In addition to search and rescue, a primary job of Lowell's ladder companies is to release smoke, heat, and gasses from buildings to allow any trapped victims to breathe and engine companies to extinguish the fire. (Courtesy of the Sun of Lowell, photograph by Michael Pigeon.)

Firefighters hose down the exterior of a building in an attempt to check the spread of a four-alarm fire involving multiple, abandoned, wood-frame tenement buildings on Hereford Place, October 10, 1973. In 1973, the department responded to 4,648 calls for service, including 30 working structure fires, 25 second alarms, 7 third alarms, and 2 fourth alarms. (Courtesy of the Sun of Lowell.)

Heavy smoke darkens the sky as firefighters in traditional rubber coats, boots, and leather helmets advance up the ladder to battle a top-floor blaze in the former Surf Hotel at 84 Bridge Street on January 5, 1974. The building, a former rooming house, was the scene of many fires. It has been recently renovated to provide more permanent housing units. (Courtesy of the Sun of Lowell, photograph by David Brow.)

At least five hoses are in operation, with three more on the way, at the general alarm fire in the closed Pratt and Forrest Lumber Company yard, during the early morning hours of August 2, 1974. In addition to leveling the three large lumber sheds, radiant heat from the fire caused homes on Sawtelle Place and the opposite side of Pevey Street to ignite. Firefighters were unable to get within 60 feet due to the intensity of the fire, and three pieces of fire apparatus were damaged. The fire was the work of an arsonist. (Courtesy of the Sun of Lowell.)

Two juveniles were arrested and charged with arson for setting fire to the three-story wooden warehouse of the Bates Tool Company on the corner of Fletcher and Rock Streets on March 11, 1975. Firefighters battle what remains of one of three buildings destroyed by the fire started with rags and kerosene. Flames from the five-alarm fire were visible in Tewksbury and Chelmsford. (Courtesy of the Sun of Lowell.)

A badly burned male is removed by firefighters from an early afternoon fire in the Bishop Markham housing complex at 65 Summer Street on September 28, 1982. Sadly the victim Henry Gonzales died of his injuries nine days later. Assisting firefighters is Deputy Chief Fred Fahey. (Courtesy of the Sun of Lowell, photograph by Robert Whitaker.)

Lowell's arson problem was at its height in the late 1970s. This abandoned building on Lagrange Street burned in a two-alarm arson fire on March 20, 1979. The same building had been significantly damaged by a fire only a year earlier, and the fire department had repeatedly asked for it to be torn down. In September 1979, firefighters would be pelted with bottles and rocks attempting to extinguish fires in the Acre and often found intentionally damaged hydrants. Department records indicate half of all fires in the city during 1978 were intentionally set. (Courtesy of the Sun of Lowell, photograph by Arthur Pollock.)

Although Lowell's firefighters do not rescue cats from trees anymore, Eugene "John" Vail rescued this one from a building fire at 100–102 Freemont Street and returned it to owner Mary Batchelder on February 17, 1981. (Courtesy of the Sun of Lowell, photograph by Robert Wallace.)

March 28, 1982, was a busy day for Lowell firefighters. A two-alarm fire struck the abandoned Shaw Hospital at 571 East Merrimack Street. The 1892 building, originally known as the E. W. Hoyt carriage house, was later a maternity hospital until closing in the 1960s. Eventually the building was renovated and converted into private residences. (Courtesy of the Sun of Lowell, photograph by Michael Pigeon.)

The same day of the Shaw Hospital blaze, fire claimed the life of a sleeping 11-year-old boy in a home on Harrison Place. The front of the Centralville neighborhood house was fully involved when Engine 5 arrived on the scene. A firefighter prepares to don his self-contained breathing apparatus (SCBA) and attack the flames blowing out the front door. (Courtesy of the Sun of Lowell, photograph by Richard Hunt.)

Lt. William Gilligan (left), of the fire department arson squad, rescued 10-month-old Steven Amaro from a building fire at 71 Westford Street, without any protective clothing or equipment available, on January 18, 1984. Gilligan was in the area when the fire broke out and is assisted in the dramatic photograph by his partner, police detective Harold Waterhouse (right). Sadly the child died two hours later. Gilligan made a similar rescue 10 months later, rescuing a woman from a Pleasant Street fire, again without protective gear. (Courtesy of the Sun of Lowell, photograph by Richard Hunt.)

Firefighters from Engine 4 race to get hoses in operation at 115 Lakeview Avenue on March 4, 1984. Despite extensive utility wires, two ladder companies are already in operation as heavy smoke vents from the upper floors and roof. (Courtesy of the Sun of Lowell.)

Firefighter Don McCarthy performs CPR on a female fire victim rescued from 49–51 Pleasant Street on March 14, 1985. The fire killed one woman and left another in critical condition. (Courtesy of the Sun of Lowell, photograph by Michael Pigeon.)

Lt. Dave Harold of Engine 2 advances a hose across a fire at the city dump located on Westford Street on September 8, 1986. In reports as far back as 1900, Chief Hosmer cited needless fires from the burning of garbage at city landfills as a problem. Often fire companies would be tied up at the scene for days as fire burrowed under the mounds of garbage. (Courtesy of the Sun of Lowell, photograph by Michael Pigeon.)

An unidentified firefighter ties off a hose after raising it up the building's exterior by rope, cutting down on the amount of hose and effort needed to stretch it up the stairs, as heavy flames roar just above his head. The second-alarm fire occurred in a boarded up tenement on November 26, 1990, at 722–724 Merrimack Street. (Courtesy of the Sun of Lowell.)

Life nets were regular equipment on ladder companies for much of the 20th century. The life net is demonstrated in 1987 by Deputy Chief Gerald Sullivan on the left and members of Ladder 3, including (clockwise from the top) Michael Donnelly, John Vail, and Lt. Gerald Peaslee. With better aerial ladders, stronger fire prevention codes, and more stringent enforcement in large buildings, and because the nets required large amounts of manpower to deploy, they are no longer carried on Lowell fire trucks. (Courtesy of the Sun of Lowell.)

# Six
# GENERAL ALARMS AND MILL FIRES

Memorial Hall and the city library on Merrimack Street were gutted by fire on March 15, 1915. The fire was believed to have started in the card and smoking room above the banquet hall portion of the building. The fire department reported the loss at $67,627.20, although war relics lost in the fire were priceless. (Courtesy of Pollard Memorial Library.)

Firemen advance hose lines via the interior and through the smoke over Truck 3's aerial ladder as shown in this view of the Memorial Hall Fire. (Courtesy of Pollard Memorial Library.)

Firemen, perched on a large ground ladder, direct a hose down into the smoldering remains of Memorial Hall late in the fire. The attic, filled with years of old books, papers, and dust, fueled flames that caused the entire roof to collapse. A newspaper account stated the librarian had asked for more shelf space a few years earlier, fearing dangerous conditions in the event of a fire. (Courtesy of Pollard Memorial Library.)

The Associates Hall Building, located on the corner of Worthen and Merrimack Streets opposite city hall, is shown at the height of the fire, which destroyed it on April 27, 1924. The water tower is visible operating an elevated water stream on the fire at the far right. The building was nearly fully involved in fire by the time first alarm companies arrived just after 12:30 a.m. It took four hours to bring it under control. (Courtesy of Dorothy Gardner-Casey.)

The shell of the Associates Building is shown in this view looking north on Worthen Street toward Merrimack Street. The wall on this side of the building collapsed on Ladder Company 4, killing Capt. Edward P. Cunningham, knocking John Gray unconscious, and injuring eight other firemen, many struck by falling bricks. The J. J. Sparks Company was completely destroyed by falling debris. (Courtesy of Dorothy Gardner-Casey.)

Twisted steel beams are visible on the second-floor level as firemen from Hose Company 10 and an assistant chief attempt to extinguish sections of the building still burning under the rubble. The fire also damaged the adjacent Mongeau Building, Academy of Music, and Knights of Columbus hall. Lawrence crews helped prevent embers from the fire from igniting other downtown buildings. Newspaper accounts stated the fire was the first time in city history outside aid was requested into Lowell. (Courtesy of Dorothy Gardner-Casey.)

A fireman looks on as he rests against the crushed ladder truck upon which his comrade lost his life. Captain Cunningham left behind a wife and three young children. John Gray regained consciousness and managed to extricate himself from the ladder. The photographs of this fire were passed down in hoseman Gray's family. (Courtesy of Dorothy Gardner-Casey.)

The Pollard Building fire, located at 124–52 Merrimack Street, threatened all of downtown Lowell's business and commercial district on June 3, 1926. This view shows the rear of the building looking down Middle Street from Palmer Street toward Central Street. (Courtesy of Dorothy Gardner-Casey.)

A massive crowd fills Middle Street as thick smoke blows through downtown. The bell tower of the Palmer Street firehouse is visible just above the J. C. Ayer building. (Courtesy of Dorothy Gardner-Casey.)

Three department members attempt to prevent the fire from jumping a Pollard building firewall with a single hose line. Smoke under pressure pushes from every seam and vent on the roof. (Courtesy of Dorothy Gardner-Casey.)

Dense smoke pouring from the building darkens the daylight at the height of the fire. Five hose lines and two master streams from the Hale Water Tower are operating in this view of the general alarm blaze. Losses to the A. G Pollard's department store, Masonic groups, and the Middlesex Women's Club totaled $1,097,476.37. (Courtesy of Bill Daly.)

On June 25, 1933, a major fire originating in the Federal Shoe Factory at Dix and Ellsworth Streets devastated portions of South Lowell. Besides the factory, 15 homes and a church were destroyed in the general alarm fire, 10 firemen were injured, and one woman was killed. Mutual aid was received by the city from as far away as Boston, Cambridge, Watertown, and Somerville. It is as close to a "Great Fire" as Lowell has ever come. Cities such as Boston, Fall River, Chelsea, and Lynn were not as fortunate as Lowell. (Author's collection.)

The Central Block, located at the intersection of Central and Middle Streets, built in 1881, contained over 60 offices and the J. J. Newberry Department Store. A general alarm was sounded for this fire on March 17, 1955, that resulted in the death of telephone switchboard operator Maude Plumstead, age 72. Damage was estimated at $1 million. Embers showered downtown buildings, causing many smaller roof fires. (Courtesy of the Sun of Lowell.)

Firefighters poised on the roof of the MERA Bowlaway building use a portable monitor pipe and two additional lines on the rear of the Central Block fire. This positioning was credited with preventing the fire from spreading to Market Street. (Courtesy of the Sun of Lowell.)

Firemen hose down the icy shell of the Mongeau Medical Arts building the morning after the December 26, 1955, fire. The building, which housed many doctor's offices, was completely destroyed in the fifth general alarm fire of the year. The fire was set with torn paper and hair tonic on the exterior of Sherwin Williams by a 22-year-old Acre resident named Walter M. Jean. Jean was later found carrying matches and gauze trying to force entry into city hall. Jean stated he was mad at the world and confessed to starting two additional downtown fires in the past month. He pled guilty to arson. (Courtesy of the Sun of Lowell.)

The Mongeau is viewed looking toward Dutton Street. The fire was fed by the contents of the paint store on the first floor. Lt. Francis McAleer sustained third-degree burns to his hands and burns to the face from an explosion that blew off the door to the Sherwin Williams paint shop, covering him in flaming paint. He was tackled and put out by Assistant Chief Leighton Gendron and fireman George Robitaille. It was said McAleer resembled a human torch. (Courtesy of Mehmet Ali.)

The Rex Amusement Center, located just outside Kearney Square on Merrimack Street, burned in a general alarm fire on June 25, 1960. The first alarm was sounded by telephone at 10:51 a.m. In addition to Lowell fire companies, 14 out-of-town companies fought the blaze. Middlesex Community College is now located on the property. (Courtesy of Robert Doyle.)

The Rex fire took over 300 firefighters and four hours to bring under control. Destroyed in the complex were 65 bowling alleys, five banquet halls, a cocktail lounge, a tavern, and a restaurant located in the old Prescott Division Plant of the Mass Cotton Mills. Lowell Fire captain Harry Doyle is visible in the foreground walking toward the camera. (Courtesy of Robert Doyle.)

Two firefighters sit atop one hose line trying to stop the advance of the fire up Rock Street on April 19, 1976. The general alarm fire destroyed five multifamily tenements in the Acre neighborhood on a windy, 90-degree Patriot's Day. The building of origin at 78 Rock Street had been the scene of previous fires. Two juveniles were charged with starting the blaze, which injured 17 people and caused over $1 million in damages. (Courtesy of the Sun of Lowell.)

The wind spread embers a half-mile from the original fire scene at 78 Rock Street to the Macheras Property on Broadway, causing a fire that destroyed historic former Locks and Canals buildings planned for part of Lowell's National Park and damaged 15 more. No Lowell fire companies were initially on the scene to fight the Macheras fire, which mutual aid fire companies responded to. More than 200 firefighters from 36 communities battled the fire. (Courtesy of Patrick McCabe Jr.)

Fire burns the entire length of a mill building located at the corner of Lawrence and Andrews Streets on Christmas Eve 1977. The general alarm fire leveled a two-story mill. Flames reached upwards of 100 feet in the air, causing millions in losses to the complex. A total of 100 firefighters from 16 communities battled the fire as 200 residents were evacuated from Andrews and Agawam Streets, many carrying Christmas gifts. (Courtesy of Thomas McCabe.)

Flames light up the outline of the complex's water tower. Multiple businesses housed in the 685 Lawrence Street Mill Complex were destroyed, and approximately 200 jobs were lost as a result. First due apparatus (apparatus assigned to respond to the initial report of a fire, known as a first alarm) were trapped by downed power lines, damaging one engine and many lengths of hose. The fire was deliberately set in two locations, and there was a previous arson attempt at the site. Chief John Mulligan had just been sworn in at the start of the week. (Courtesy of Thomas McCabe.)

Lowell Ladder 1 tries to stop the advance of flames from the Krikor Street side of a seven-alarm fire that destroyed the former American Hide and Leather Factory on Perry Street on April 23, 1978. Smoke from the fire was visible as far away as the Tobin Bridge in Boston, and the Portsmouth, New Hampshire, rotary. It took over seven hours to bring the fire under control, which also damaged many homes. The Stoller Manufacturing Company Warehouse in the mill was destroyed. Water pressure problems from older dead-end water mains contributed to the difficulty fighting the fire. (Courtesy of William Noonan.)

An estimated 300 firefighters from over 30 communities responded to the fire. Heavy flames are shown blowing out windows on the Perry Street side of the building, and portions at the far end of the complex have begun to collapse. (Courtesy of the Sun of Lowell, photograph by Robert Wallace.)

Looking up Perry Street from the corner of Rogers Street, the complete collapse of the mill is visible. Steel shutters at the mill building's far end and the efforts of firefighters prevented the fire from extending to the occupied homes on the right, which still stand. Firefighters are seen spraying water in the narrow space between the building and the burning debris pile. (Courtesy of LFD.)

Shown is the destruction of the former America Hide and Leather Factory as viewed from the air on April 24, 1978. Firefighters were on the scene for over a day, as a crane was brought in to provide access to burning material under the collapse debris. (Courtesy of the Sun of Lowell, photograph by Richard Hunt.)

Lowell also responds on mutual aid requests to other communities. Aid has been sent as far as Boston in 1889, Newburyport in 1934, and Lynn, where Lowell Ladder Company 3 is operating at the second great Lynn Fire, on November 28, 1981. A total of 26 buildings were involved in the Lynn fire, which was not out until December 14th. (Courtesy of James Quealey.)

Deputy Chief Patrick McCabe discovered this fire at the Lowell Manufacturing Company on Market Street on February 7, 1979, while returning from another call. Arson was believed to be the cause of the fire, which reached six alarms. The five-story mill building now houses apartments and the Lowell National Historical Park Visitors Center. (Courtesy of the Sun of Lowell, photograph by Bob Wallace.)

Heavy fire roars out the top-floor windows of the Lowell Manufacturing Company on Market Street, opposite Shattuck. It was the second fire on the top floor of the former Stuart's Department Store and New Market Manufacturing Company in less than two years. The sprinkler system was never repaired after the first fire. Two teenagers were later charged with setting the fire. (Courtesy of the Sun of Lowell, photograph by Bob Wallace.)

A nine-alarm fire ravages the Lawrence Mill Complex on March 23, 1987. The fire was first called in by off duty fire Lieutenant John McGaughey at 5:42 p.m. The fire originated in the Sweeney building at the center of the mill complex and burned for nearly nine hours before 200 firefighters from 17 cities and towns could bring it under control. Crews were on the scene for days putting out hot spots. The Lawrence Mill Building at right was saved from destruction and converted to condominiums in 2006. (Courtesy of Robert Stella.)

A lone firefighter stands atop an aerial ladder, pouring water into the Lawrence Mill inferno. The scene is reminiscent of a city bombed in wartime. The towers of the Sweeney Building in the background had been the centerpiece of a planned $300 million expansion of the University of Lowell. The fire contributed to those plans going unrealized. (Courtesy of Gerry Lavallee.)

# Seven
# CALL THE FIRE DEPARTMENT

Members assigned to the Lowell Fire Department ambulance are pictured loading a patient in 1941. The American Legion Post donated the gray Packard in 1940 shortly after the fire department took over the service from the police. Today a private company provides ambulance service. (Courtesy of Dorothy Gardner-Casey.)

The department employs a full-time mechanic to keep the equipment moving. Here fire mechanic Warren "Squash" White works on the large 1930 Ahrens Fox Engine. (Courtesy of Gerald Deschene.)

Fire alarm operators man the switchboard and fire alarm telegraph system in the former Palmer Street Headquarters around 1965. Eight ticker tape punch registers stand to the left. In 1912, the city fire alarm boxes were renumbered and divided into eight separate districts. The fire alarm box numbering system, by which the first number rung on the bells indicates the section of the city the box is located in, still exists to this day. (Courtesy of Robert Washburn.)

House watch duty was a regular part of the job in this photograph from Engine 7 around 1950. It was the responsibility of the person on watch at the desk to note the location of calls and greet any visitors to the firehouse. (Courtesy of Patrick McCabe Jr.)

This Ferris wheel rescue took place on May 14, 1971, at the St. Louis Carnival on West Sixth Street. A cable powering the ride snapped, causing the wheel to stop rotating. The rescue effort took over an hour, removing a total of 30 people. Firefighters Ray Ducharme and Lucien Latulippe evacuated trapped riders using Ladder 4's aerial while Leon Fontaine operated the ladder controls. (Courtesy of Bill Daly.)

Firemen Larry Brule, Gerry Lavallee, and George Rogers of the rescue company stand at a manhole from which they and Capt. William Gillick rescued Henry Sequin. Sequin was working at the site of the new water treatment plant on Pawtucket Boulevard in 1963 when he fell 20 feet into the manhole and was injured. (Courtesy of George Rogers.)

Gerry Lavallee, a 20-year veteran firefighter, demonstrates the use of a rope hauling system he invented on Warren Street, on December 12, 1979. The system was designed to lower a firefighter and a stokes basket into bodies of water to rescue victims. The system attached to the top of an aerial ladder using a block and tackle. (Courtesy of LFD.)

Donald Garner (left), district arson coordinator for Factory Mutual Insurance, checks out the equipment in the new arson squad vehicle used by inspector Harold Waterhouse (center) and Lt. William Gilligan (right) in October 1978. Arson was a major problem in the city as industry moved out and abandoned property increased. The squad was formed in 1977 as a response to the sharp increase in arson fires through the 1970s. In the first year, Waterhouse and Gilligan investigated over 40 fires and successfully recorded 12 convictions. In their first four years of full-time operation, they never lost a case. (Courtesy of the Sun of Lowell, photograph by David Brow.)

Fire investigators Bob Doyle (left) and Gerry McCabe (right) search for the area of origin of this fire on Broadway Street on December 12, 1990. Massachusetts law states it is the responsibility of the fire department to investigate all fires for origin and cause. (Courtesy of the Sun of Lowell, photograph by David Brow.)

Three Lowell engine companies also operate three rescue boats and two hovercrafts for water rescue incidents on the city's rivers and many canals. This rescue of Joey Palladino and Jason Malave took place on the Merrimack River, one half-mile upstream of the Sampas Pavilion on February 19, 1992. (Courtesy of *the* Sun of Lowell, photograph by Michael Pigeon.)

Firefighters work to extricate the victim from this serious accident at the intersection of Middlesex and Walker Streets on August 7, 1990. The hydraulic extrication equipment including cutters, spreaders, and rams are visible at the bottom center of the photograph. (Courtesy of the Sun of Lowell.)

Since the mid-1990s, Lowell firefighters have responded to all life-threatening medical emergencies. All fire companies are equipped with automatic cardiac defibrillators. Here firefighters perform CPR and assist paramedics carrying a cardiac arrest victim from a scene on Phoenix Avenue. (Courtesy of the Sun of Lowell, photograph by Bill Bridgeford.)

Engine companies are required to stand by for all medical helicopter landings in the event of an emergency. Here Engine 3 stands by for a Boston Medflight landing in the parking area of Saints Memorial Medical Center on Nesmith Street. Firefighter Barry Gannon, at far right, assists medical personnel in loading the patient for transport to a Boston hospital. (Courtesy of the Sun of Lowell, photograph by David Brow.)

Fire alarm operator Jim Peretti is shown working the fire department dispatch console at the JFK Civic Center on Thanksgiving Day in 1977. At the time, the plug switchboard, punch time clock, and telephone headset radios were still in operation and apparatus was dispatched using a pull card system. Computerized dispatch came to the department in the 1990s. (Courtesy of the Sun of Lowell, photograph by David Brow.)

In 1888, fire department members began inspecting buildings in an attempt to reduce fire risk and familiarize members with buildings. In 1913, a systematic inspection system was implemented with each company being assigned a district and submitting written violations. The Fire Prevention Bureau was established on May 1, 1929, and the number of inspections conducted tripled. Pictured is Inspector John Vail conducting a code violation check in a High Street building on November 26, 1991. (Courtesy of the Sun of Lowell, photograph by Richard Hunt.)

Firefighter Larry Peaslee shows off Engine 6 to students at the Greenhalge School during Safety Day, May 11, 1989. Despite being dwarfed by the tires of the engine, almost every kid is eager to take their turn sitting behind the steering wheel. Demonstrations by firefighters at local schools are designed to teach children what to do in the event of a fire in their home or school and familiarize them with the job firefighters do. (Courtesy of the Sun of Lowell.)

Hazardous materials have become an increasing part of the fire department's workload. Protection of life, property, and the environment are the goals of haz-mat response. Here Capt. Lenny Rapone attempts to contain a gasoline leak from a tank truck on Dutton Street, on February 20, 1985. Today Lowell has one of the highest percentages of hazardous materials technician certified firefighters in Massachusetts. (Courtesy of the Sun of Lowell, photograph by Michael Pigeon.)

One responsibility of Lowell Firefighters is to ensure access and check the operability of all the city hydrants in the event of a fire. In addition to yearly hydrant inspections, firefighters check each hydrant in their company's district after snowstorms and shovel them out if necessary. From left to right, Engine 5's crew of Lt. Charles McSwiggin, Phil Demers, and Andrew Lacourse shovel out a hydrant on Beacon Street at 11:30 p.m. on January 20, 1978. (Courtesy of the Sun of Lowell.)

It is not always fires and rescues. Daily housework is a regular part of the job. Whether doing dishes, taking out trash, cleaning the bathroom, or mopping floors, as Kevin Burgoyne does in the kitchen of the Mammoth Road firehouse, life in the firehouse has the same chores as at home. (Courtesy of Gerald Roth.)

# Eight
# OFF THE JOB

Shown is an early firemen's ball ticket dated 1861 from the Ex-Five Associates. The individual fire companies held the events in the early years of the department. The firemen's ball was a popular social occasion in the city. Beginning around 1885, the ball began to be sponsored by the entire department membership, instead of individual fire companies. The plan, according to reports, was to run an annual ball hereafter to benefit the Firemen's Fund Association. Organized on December 17, 1853, the fund afforded relief to members injured in the discharge of their duties. In 1932, the ball was large enough to be held in the Lowell Memorial Auditorium. Except in times of war, the firefighter's ball has been an annual event for over 100 years. (Author's collection.)

The Palmer Street apparatus floor is turned into a banquet hall for more than 300 attendees sending off retiring chief of department James Sullivan after 49 years of service, on June 27, 1939. The meal served was roast turkey and ham, mashed potatoes, and vegetables, along with entertainment by Campbell's Orchestra and the Donahue Brothers. The large group of speakers,

from all across the fire service, included Boston fire chief Samuel Pope, Brookline chief Selden Allen, state fire marshal Stephen Garrity, and new Lowell fire chief Charles Stackpole. Chief Sullivan deflected much of the accolades, stating credit should be given where due, to the men who put out the fires, whom he would never forget. (Courtesy of Robert Doyle.)

The American Legion Convention took place in Lowell, and its procession made a stop to pose with members of Engine 7 at the Pine Street Station during 1946. (Courtesy of Dorothy Gardner-Casey.)

The campaign to end the 70-hour workweek took place in 1947. Voters approved the workweek reduction to 48 hours for firemen. The cards were printed on both sides so even if discarded the card's message could be viewed wherever it lay. The more accurate term firefighter came into use as members became more organized in their labor efforts. The Lowell Fire Fighters Local 853 organized and became affiliated with the International Association of Fire Fighters on May 26, 1946. (Courtesy of Joe Saugeties.)

The Boston Fire Department American Legion Post Band paid a visit to Lowell, playing at the Harvard Brewery in 1948. Attending the event, from left to right, are James F. Donohue, Harvard Brewing Company treasurer; Lowell fire chief Charles F. Stackpole; Boston fire chief Napeen Boutilier; and Walter Guyette, president of the Harvard Brewing Company and the event's host. (Courtesy of Dorothy Gardner-Casey.)

Members of an outing planning committee posed for a photograph include, from left to right, Tom Burke, Dick Baldwin, Chief Walter Kane, Bill Dempsey, Ted Bukala, and Tony Cassella. (Courtesy of LHS.)

117

The Lowell Firefighter's Outing, held annually, usually involves an all-day barbeque or buffet, sports, and game tournaments. Through the years, softball, golf, horseshoes, shuffleboard, checkers, chess, and card games have all been contested between Lowell and local town

118

firefighters. Firefighters attending the outing are shown at the Tyngsboro Country Club on July 28, 1953. (Courtesy of LHS.)

Firemen pose for a photograph before leaving the Palmer Street station on a house-to-house campaign for funds to fight muscular dystrophy, on December 10, 1956. From left to right are (first row) Raymond Rafferty, John McCullough, Harold Lee, Leon Fontaine, Lt. Hugh Campbell, Anthony Blazonis, and Lt. Robert Lemire; (second row) Richard Baldwin, John Wojtas, Frank Donnelly, Albert Laferriere, and John Nelson. (Courtesy of Bill Daly.)

Seated at the head table for a retirement party, from left to right, are Chief Kelleher, retiree Andy McGlouhlyn, Lieutenant McCarthy, and Lieutenant Gildea in Engine 7's quarters, in August 1957. The send off is a traditional house party, held right on the apparatus floor among the hose racks. (Courtesy of Leo Sheridan.)

Planning Memorial Sunday at a meeting in Engine 8's quarters on May 17, 1957, are, from left to right, (standing) Capt. William J. Corbett, secretary treasurer Gerald L. Deschenes, and Lt. Robert J. Lemire; (seated) *Lowell Sun* reporter and publicity chairman Fred W. Dudley, union president Harold J. Lee, general chairman Leon E. Fontaine, Lt. Raymond J. Geoffroy, and Nap Grandchamp, in charge of retired men. (Courtesy of Bill Daly.)

Led by a combined armed forces color guard, Chief Kelleher, members of city government, and Lowell, Tewksbury, and Billerica firefighters march down East Merrimack Street en route to St. Joseph's shrine on Lee Street to attend mass in observance of Firefighters Memorial Sunday on June 9, 1957. The mass was celebrated by Rev. James Flanagan, followed by the communion breakfast at the Knights of Columbus. Rev. Flanagan was also presented with a gold badge, white helmet, and white coat as department chaplain. All present were given medals of St. Florian, patron saint of firefighters.

The 1961 Lowell Fire Department Softball Team poses for a team picture outside the Centralville Social Club on Lakeview Avenue. From left to right are (first row) W. Gillick, G. Lavallee, F. Laferriere, G. Owens, D. Correa, E. Linnehan, and T. Rogers; (second row) G. Cushing, L. Sheridan, N. Sayer, and E. Charron; (third row) V. Cote, T. Burke, L. Brown, and A. Blazonis. The Gillick children are seated next to their father at left. (Courtesy of Gerry Lavallee.)

A large group of department members pose outside the West Sixth Street firehouse before a charity fund-raising campaign in the 1960s. Pictured from left to right are (first row) Leo Kelly, R. Vallerand, Lt. Mike Lee, Jim McShane, Tom Rogers, Rene Gendreau, Dick Baldwin, Julian Olejarz, Chief Walter Kane, Lt. William McCarthy, J. Nelson, Gene Laferriere, and Capt. J. Gallego; (second row) Lt. James O'Brien, Jim Nelligan, Leon Fontaine, Capt. Tom Finneral, Les Brown, Capt. Tom Comer, Paul Richards, Lt. Fred McSwiggin, Capt. Tom Conlon, Lt. Jerry Owens, Al Laferriere, Vic St. Jean, Bill Ryan, Don Carroll, John Daly, Lt. Leo Curran, Frank Christoun, Ed Linnehan, John Wojtas, Hank McCabe, Lt. Hugh Campbell, Capt. Bill Baldwin, and John Dowling. (Courtesy of John Dowling Jr.)

On September 27, 1968, the first collective bargaining agreement between the City of Lowell and Lowell Firefighters Local 853 was signed. The contract called for the implementation of the 42-hour workweek and effective November 2, 1969, a top step weekly salary for firefighters of $150.41. Seated at the table, from left to right, are Anthony Cassella, Fire Chief Walter Kane, city manager Charles Gallagher, Larry Brule, and George Rogers. Standing are Fred Jeffers, assistant city solicitor David Fenton, William Gillick, attorney Phillip Nyman, and Thomas Burke. (Courtesy of George Rogers.)

The 1972 fire department softball team included, from left to right, (first row) Lenny Rapone, Gerry Lavallee, Jack Plunkett, Jerry McCabe, George Rogers, and Jerry Peaslee; (second row) Stanley Tarsa, Gerry Sullivan, Bob Keefe, Billy Lake, Ray Grenier, Jim Quealey, Paul Prud'home, Eugene Laferriere, and Dick Caveney. Missing are Bill Cronin, Leo Calhoun, and Ray Keefe. (Courtesy of Gerry Lavallee.)

Lowell firefighters parade down Merrimack Street just before city hall with an antique hand engine in the early 1970s. Jerry Lewis and Ed McMahon visited Lowell for an Muscular Dystrophy Association benefit, which the parade was a part of. Members in the procession included Bob Kaye, Jim Quealey, Jack Lake, Paul Prud'homme, and Jack Quigley. The engine is "Hero" from Billerica. (Courtesy of Jim Quealey.)

Area firefighters present a check to muscular dystrophy patient Darren Roberge at the Branch Street firehouse on October 18, 1974. With Roberge, from left to right, are Merrill Marshall, Tewksbury Fire Department; Bill Daly, president of Lowell Firefighter's Local 853; and William Mangan, president of Billerica Firefighters Local 1495. (Courtesy of the Sun of Lowell, photograph by David Brow.)

Lowell Firefighters Pat McCabe Jr. and Ray Keefe man the nozzles during a firemen's muster demonstration at the Regatta Field on Pawtucket Boulevard. Firemen's musters have been held in the city for nearly 150 years. One of the largest musters took place on August 20, 1908. (Courtesy of Patrick McCabe Jr.)

Chief Mulligan (left) purchases the first raffle ticket sold by members of the Lowell Firefighters Association to raise funds to open the Lowell Firefighter's Club, on April 29, 1979. With him are Firefighter's Association members Larry Brule (center) and Larry Sullivan. (Courtesy of the Sun of Lowell.)

Runners race up Merrimack Street as part of the Lowell Firefighters Road Race, one of many sporting events and teams sponsored by Lowell Firefighters Local 853 annually. Racer number 1019 is Lt. Paul Cronk of Engine 4. (Courtesy of Paul Cronk.)

The Lowell Firefighters Credit Union was chartered as the Lowell Firemen's Club Credit Union on December 8, 1936, with Edmond A. Gendreau as treasurer. Originally located on the second floor of the Lawrence Street firehouse, credit union membership is open to Lowell firefighters, pensioners, their immediate families, and firefighters from surrounding towns. Pictured from left to right are credit union officers and staff members Frank Ahearn, James Fallon, and Gerald Peaslee, all former Lowell firefighters. (Courtesy of Lowell Firefighters Credit Union.)

Led by the Local 853 honor guard of, from left to right, Brian Callahan, Dennis Bergeron, Jim Nutter, Lenny Rapone, Phil Gauvreau, and Ray Keefe, Lowell firefighters march for Firefighters Memorial Sunday on June 14, 1981. (Courtesy of the Sun of Lowell, photograph by David Brow.)

Firefighter David Wallace stands holding his daughter Christine at the Firefighter's Memorial Sunday Service. (Courtesy of the Sun of Lowell, photograph by Bill Bridgeford.)

Deputy Chief Andrew Lacourse kneels to place a flower in memory of a deceased firefighter at the foot of the firefighter's memorial in June 1989. Lacourse would go on to lead the department as chief from 1993 to 2001. As chief, Lacourse was responsible for the department changing to the use of turnout gear and large diameter hose and the purchase of many new apparatus.

A department member lays a wreath to honor the memory of all deceased Lowell firefighters on June 13, 1982. The firefighters monument, located in front of the civic center firehouse on Moody Street, was dedicated on June 5, 1977. That year the first outside memorial mass was conducted, a tradition that continues on the second Sunday of June each year. (Courtesy of the Sun of Lowell, photograph by David Brow.)